THIS IS ISRAEL
PICTORIAL GUIDE AND SOUVENIR

New Edition

Prayer for Peace

This beautiful book, illustrated with 614 spectacular pictures by Israel's leading photographers, is an ideal souvenir and a perfect gift for everyone interested in Israel, the Holy Land, a cradle of civilization.

Here you will find the history and descriptions of all the main sites - from Jerusalem, with its holy places, through the Dead Sea and the Negev desert, to biblical cities and archeological sites, from lively modern cities and seaside resorts to the lush Galilee and exotic Eilat.

Israel is a rich kaleidoscope of people, faiths, archeological remains, historical sites, diverse landscapes and dynamic cities, ancient and modern side by side.

We are grateful to all those who assisted in the publication of this up-to-date book:
photographers, publishers, The Israel Museum Jerusalem, The Rockefeller Museum, Israel Department of Antiquities, Holyland Corporation, the Temple Institute, The Nature Reserves Authority, Yad Vashem and other museums and institutions. Dolphins' photographs by kind permission of Dolphin Reef, Eilat. Hi-tech photographs by kind permission of Weizmann Institute and Jerusalem College of Technology.

Text: N.A. Beecham
Design: Studio Adi Tsur
Chief Photographer: Garo Nalbandian
Photographers: Albatross, R. Belchasan, L. Borodulin, W. Braun, H. Dorfzaun, Yossi Eshbol, R. Eviatar, D. Harris, S. Ginot, Itamar Grinberg, J. Hazut, G. Ilan, Hanan Isachar, R. Kowalsky, H. Krackenberger, Tony Malmquvist, Z. Mautner, S. Mendrea, Amit Netzer, Doron Nissim, R. Nowitz, Gilad Peli, Osku Puukila, Z. Radovan, O. Reinhartz, G. Rubin, J. Sahar, A. Shabataev, Y.N. Schwartz, A. Zadok.
Maps & Illustrations: C. Ron.
Image Processing: Nesher Aerial Photography and Information Systems, Herzlia, Israel.

ISBN: 978-965-280-145-6

CONTENTS

Bethlehem, Jericho, most of Hebron, areas in Judea and Samaria and the whole Gaza Strip are under Palestinian jurisdiction.

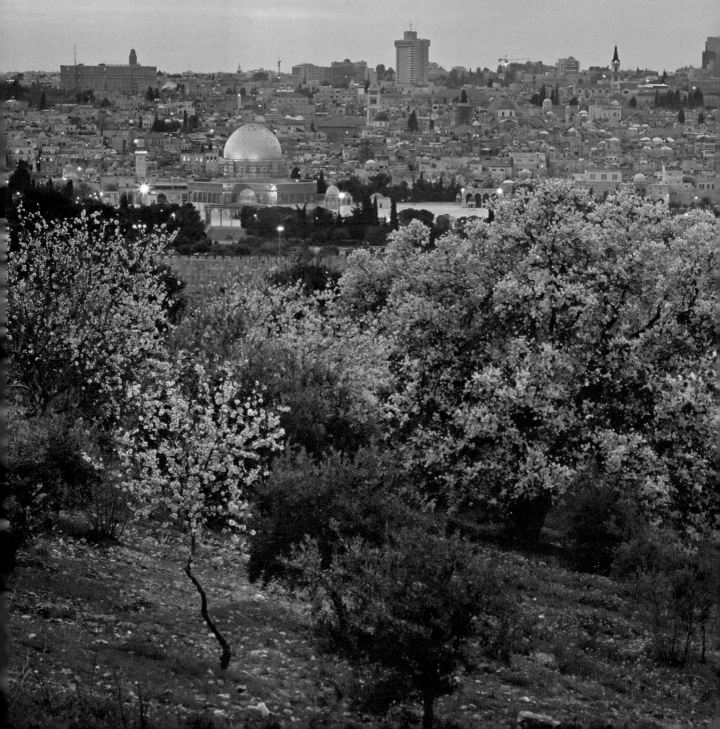

"Our feet are standing within thy gates,
O Jerusalem.
Jerusalem, that art built as a city that is
compact together."

(Psalms 122:2-3)

INTRODUCTION

The story of Israel spans many thousands of years. Bridging Africa, Asia and Europe, crossed by highways and major trade routes, it has always been an important strategic point. A cradle of mankind, history can be traced back to the Bronze Age to the time of the Patriarchs who settled in the Land. Forced by famine to migrate to Egypt, after Joseph's death the Israelites were enslaved until Moses led them out and after 40 years wandering in the desert they came to the Promised Land. Jerusalem was made the capital of the kingdom under the rule of King David. The Babylonian exiles, the Hellenistic period, the Second Temple, Jesus' Ministry, Roman and then Byzantine rule, the Crusades, the Ottomans and finally the Zionist movement are all part of the turbulent history of the Land, until the State of Israel was established on 15th May 1948. The ranks of the Israeli citizens were quietly swelled by the arrival of Jewish immigrants who streamed in from the neighbouring Arab countries anxious to return to their homeland. A modern miracle occurred as these people were settled, cared for and trained to take their place in the new state. Their totally different ethnic backgrounds and cultures have now blended together in the melting pot of Israeli life.

Hopes for tranquillity in this troubled area have so far not been fulfilled and efforts at negotiation continue in the hope that eventually there will be a lasting peace.

Turning to the land itself, it is indeed difficult to visualize so much variety in such a small country. Snow-capped mountains, fertile valleys, arid and desolate desert, sparkling lakes and sea-side resorts are all to be found within the boundaries of Israel. The hustle and bustle of towns, noisy local markets, the sanctity of the holy places and a close association with the Bible all wait to be experienced by travellers of all ages and interests from all walks of life.

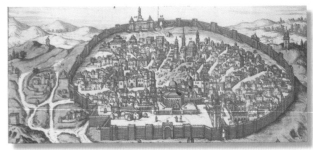

16th century map of "Jerusalem in the Midst of the Nations" by George Braun and Frans Hogenburg

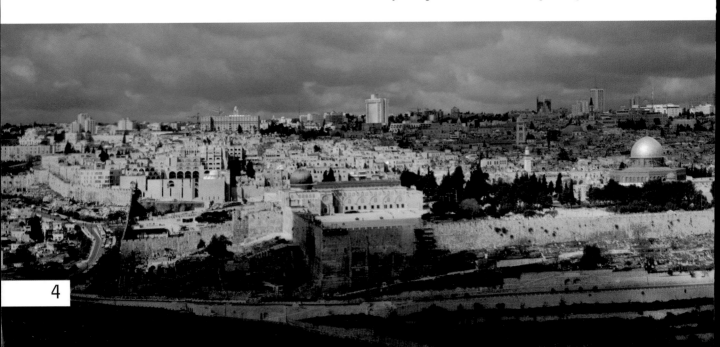

JERUSALEM

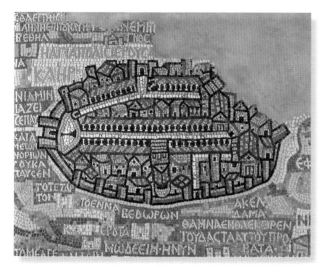

Jerusalem as depicted in the center of the 6th century Madaba mosaic map of the Holy Land and its neighbors, discovered in a church in Jordan.

Jerusalem, city of a hundred names and a thousand faces, holy to Judaism, Christianity and Islam is undoubtedly the jewel in the crown that is Israel. Abraham's near sacrifice of Isaac on Mt. Moriah, David's establishment of the small Jebusite town as his capital and Solomon's construction of the Temple enshrined Jerusalem in the hearts of Jews forever.

Panoramic view of Jerusalem.

Throughout the almost two thousand years since the destruction of the Second Temple and the exile, Jews the world over have prayed in the direction of Jerusalem. Christians connect Jerusalem with the last years in the life of Jesus. Here he taught, was arrested, crucified and resurrected. Moslems associate Jerusalem with El Aksa, the point from which Mohammed ascended to the Seventh Heaven. After Mecca and Medina, Jerusalem is Islam's third holiest city.

Jerusalem's sanctity and mysticism have inspired prophets, artists, poets and scholars throughout the ages. But it has also become a major cultural center with museums, galleries, theatres, universities and yeshivot and the presence of the supreme legislative administrative and judicial bodies have made it into a modern capital. Archeological remains from different periods, religious monuments and Jewish neighborhoods all claim the attention of the many visitors. The variety of costumes which rub shoulders in its streets – Hassidic capotas, Moslem jalabiyas, different monks' robes, denim jeans and many, many more combine with the harmony of church bells, the muezzin's call to prayers, the chanting of yeshiva students and dealers offering their wares to make this a fascinating, unique city.

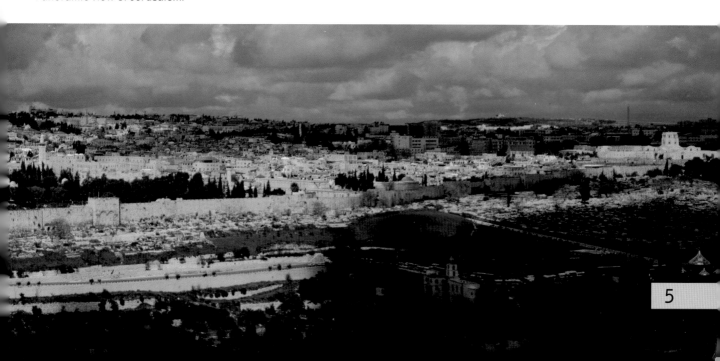

THE GATES

There are eight gates in the Old City walls.

Damascus Gate – this is the most ornate gate and was built by Suleiman the Great in 1537. The road to Damascus and the north used to start here. Excavations have revealed part of a gigantic Roman archway.

The New Gate – the only gate not built by Suleiman. It was opened in 1887 to facilitate passage from the Christian Quarter to the Catholic institutions outside the walls.

Jaffa Gate – this was the starting point of the road to Jaffa, an important port town, and so an outlet for trade.

Zion Gate – connects the Armenian Quarter with Mount Zion. It has also been called the "Jewish Quarter Gate" because of its proximity to the Jewish Quarter.

The Dung Gate – this is the nearest gate to the Western Wall. It is low and narrow – just wide enough to permit the passage of a man and his donkey. Much of the city's refuse is taken to the Kidron Valley by an ancient sewer which runs beneath this gate.

The Golden Gate – situated in the east wall of the Temple Mount enclosure, facing the Mount of Olives, it is also known as the Gate of Mercy. The gate was sealed many years ago by the Turks. Jewish tradition holds that the Messiah will enter Jerusalem through this gate.

The Lions' Gate – named for the pair of carved lions who guard it. The gate is also known as St. Stephen's Gate; according to tradition Stephen was martyred nearby.

Herod's Gate – named for the mistaken identification of a church nearby as the home of Herod Antipas. Decorated with a rose-like design, in Hebrew it is called "The Gate of the Flowers". It was closed until 1875.

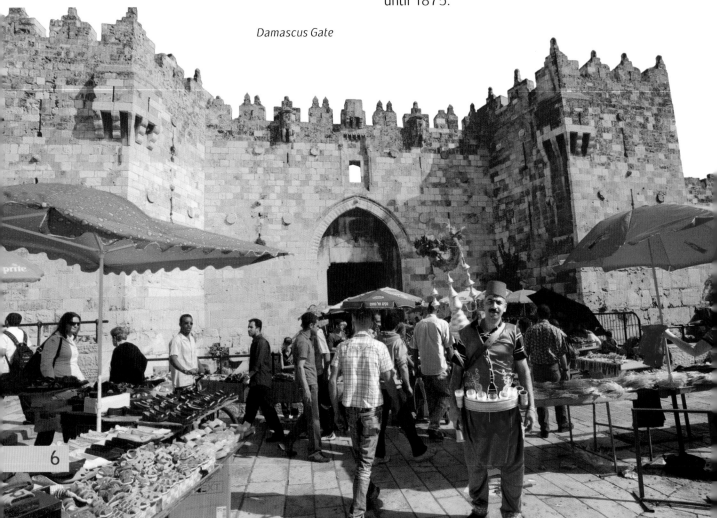

Damascus Gate

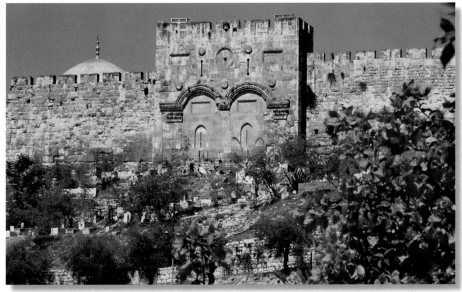

Flights of steps lead to the ramparts walkway which runs round the top of the Old City walls. There are four routes, each providing a breathtaking view of the Old City of Jerusalem.

The Gates of Jerusalem.
top: The Golden Gate
center, right to left: Jaffa Gate,
St. Stephen's or Lions' Gate, Zion Gate
bottom: The New Gate, Herod's Gate,
The Dung Gate

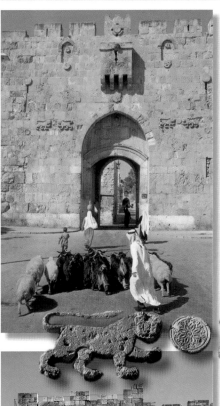

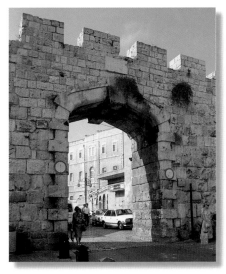

THE OLD CITY

The Old City of Jerusalem is composed of four quarters, each with its own distinctive characteristics. The Christian Quarter is in the north-west; the Moslem Quarter in the north-east; the Armenian Quarter in the south-west and the Jewish Quarter in the south-east.

These four quarters, covering an area of approximately 850 dunams, are surrounded by the city walls. Built of huge blocks of grey stone, the present walls were constructed between 1536 and 1539 during the time of Suleiman the Magnificent.

left: Old City wall with the Citadel.
below: Courtyard of the Citadel.
bottom: East Jerusalem, with the Old City wall and Damascus Gate on the right.

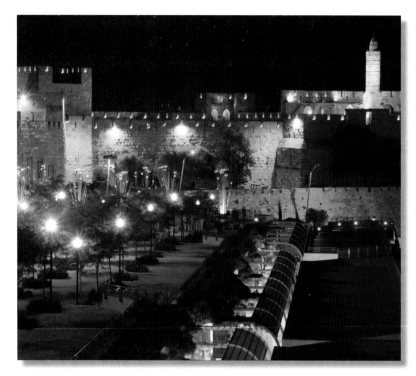

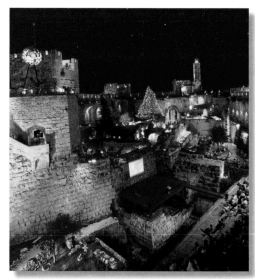

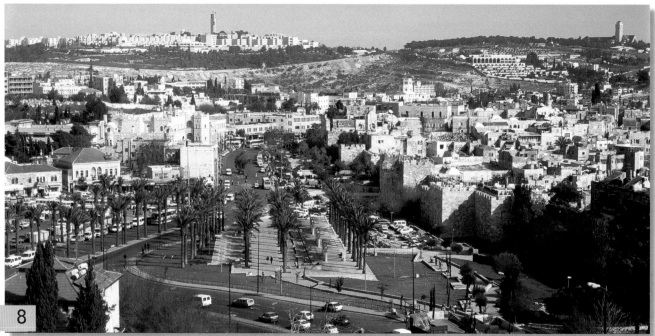

THE CITADEL

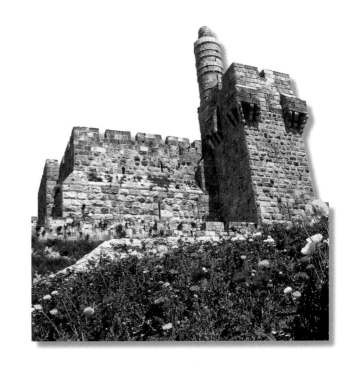

On the western side of the Old City, the massive structure of the Citadel looms large and overpowering. It stands on the site where Herod built his palace at the end of the first century B.C.E. and the enormous stones comprise some of his most impressive and important fortifications. Only this part of the city wall remained intact after the destruction of Jerusalem by the Romans. The Tower of Phasael just inside Jaffa Gate, mistakenly known as David's Tower, is a Jerusalem landmark to this day. From its roof there is a superb view of the Old City.

The building has been turned into a museum which presents the three-thousand year history of Jerusalem through the ages with state-of-the art displays and exhibits using the most advanced technologies. During the summer months, visitors can enjoy audio-visual presentations and concerts against the wonderful backdrop. The courtyard has been excavated and finds from many different periods have been discovered.

below: The Citadel as seen by David Roberts, the English artist, in 1839.

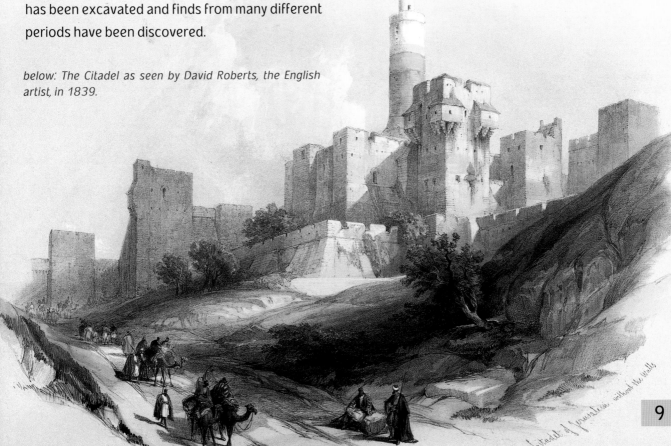

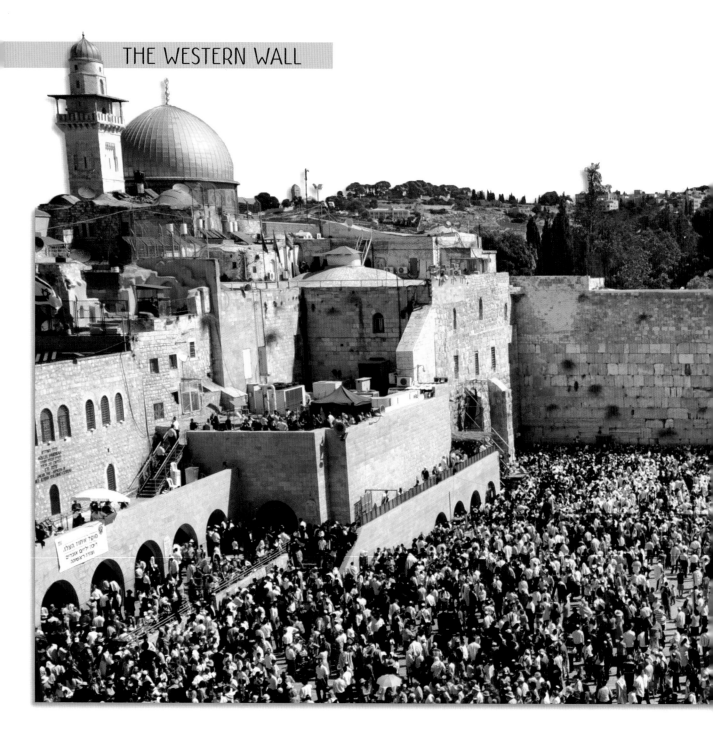

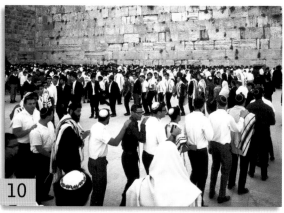

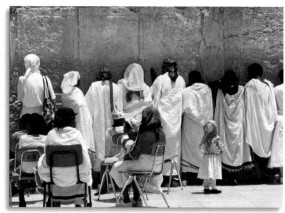

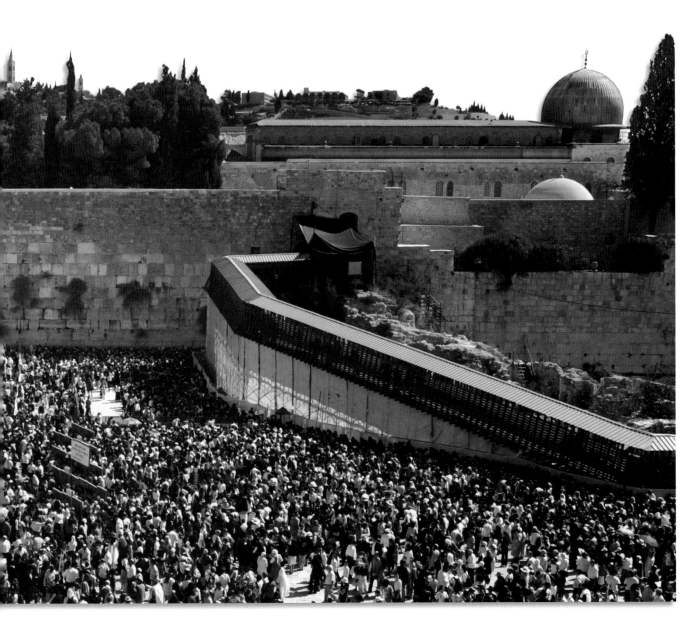

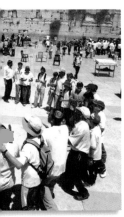

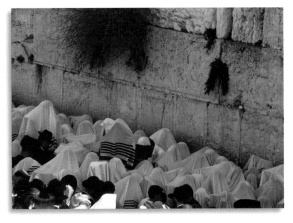

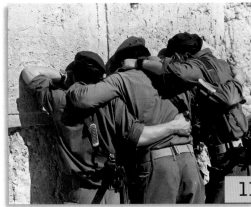

The Western Wall, also known as the Wailing Wall, is all that remains of the Second Temple and pilgrims from all over the world gather to pray here. After the reunification of Jerusalem following the Six-Day War in June 1967 the site was cleared, the crowded hovels around it were pulled down, and a vast paved plaza was constructed. At any hour of the day or night, winter or summer, Jews are to be found standing in front of the Wall in devout prayer, some placing their messages in the cracks and crevices between the stones. These great Herodian stones rest one on top of the other without cement between them to hold them in place and more than half of the wall is below the present day ground level. A tunnel has been dug about 50 feet below ground level along the entire length of the ancient wall revealing remains of a 2000 year old street, cisterns, a Hasmonean-period aqueduct and other finds. Today, tourists can walk through the tunnels, beneath the houses of the Old City, and imagine ancient Jerusalem in all its glory.

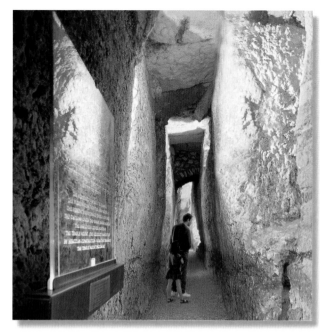

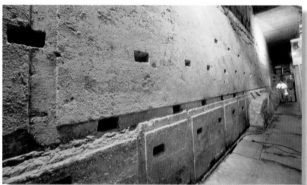

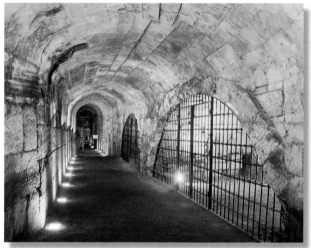

top: The southern section of the Hasmonean water channel
center: The largest stone of the Western Wall, weighing 570 tons and 44 feet (13.6m) long.
above: The "Secret Passage" – entrance to the Western Wall tunnels.
left: Part of the Hasmonean street near the northern end of the Western Wall.

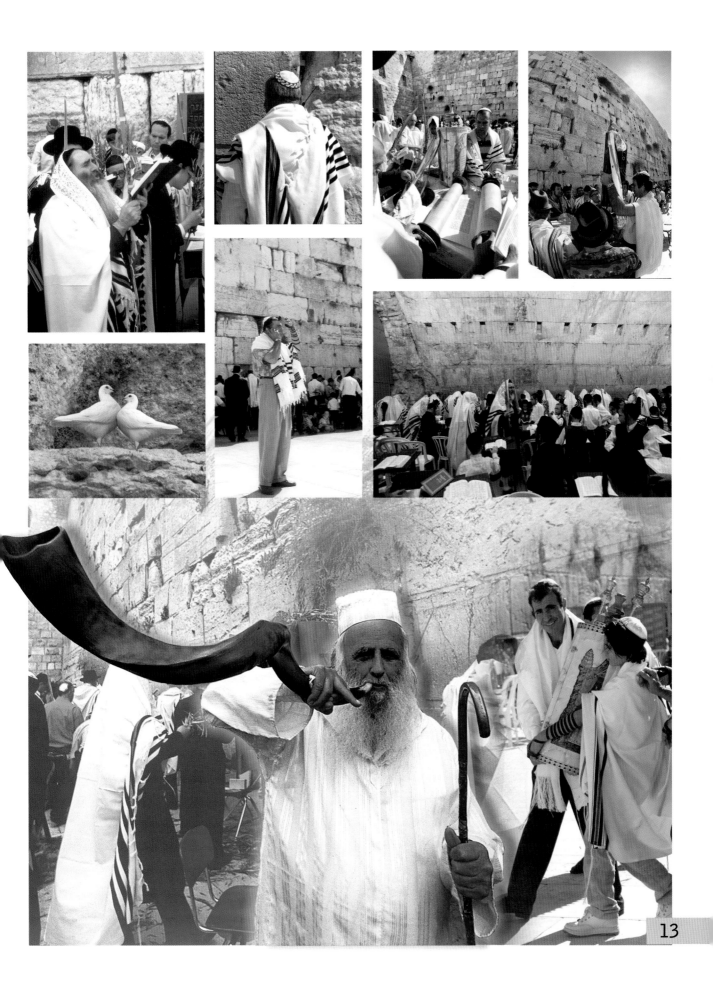

THE JERUSALEM ARCHEOLOGICAL PARK

The excavations along the southern and western wall of the Temple Mount have revealed dramatic discoveries of Jerusalem at the time of the Second Temple. A Herodian street, Robinson's Arch which supported a flight of stairs leading from the street to the Temple Mount, ritual baths, Byzantine residences and remains of later periods – Islamic, Crusader and Mameluk. At the bottom of the southern wall, the Ophel area, the visitor can climb the original stairs of the Hulda Gates leading to the Temple Mount. Within the park is the Davidson Visitors' Center which displays and explains the history of the Temple Mount with visual aids and a virtual reconstruction of the Temple.

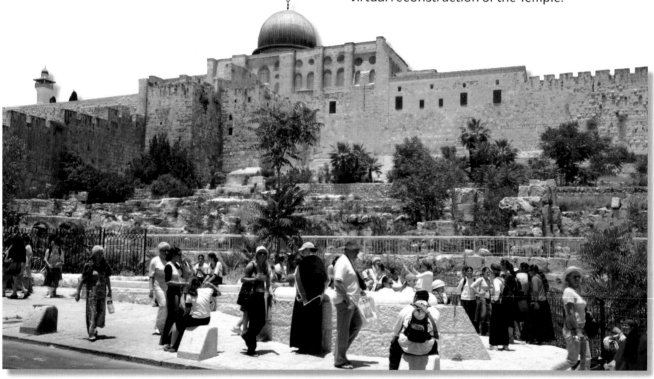

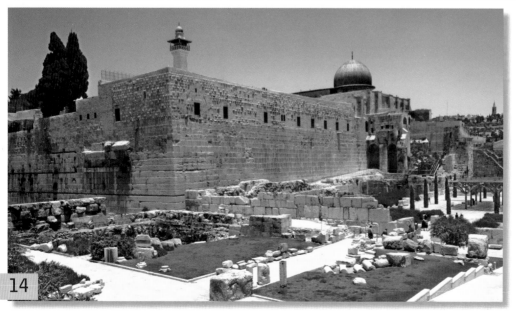

above: The southern wall excavations with the cupola of Al Aksa Mosque. left: Excavations outside the southwestern corner of the Temple Mount; the remains of Robinson's Arch jut out from the wall. opposite: The Hulda steps in the southern wall, which led into the Temple courtyard.

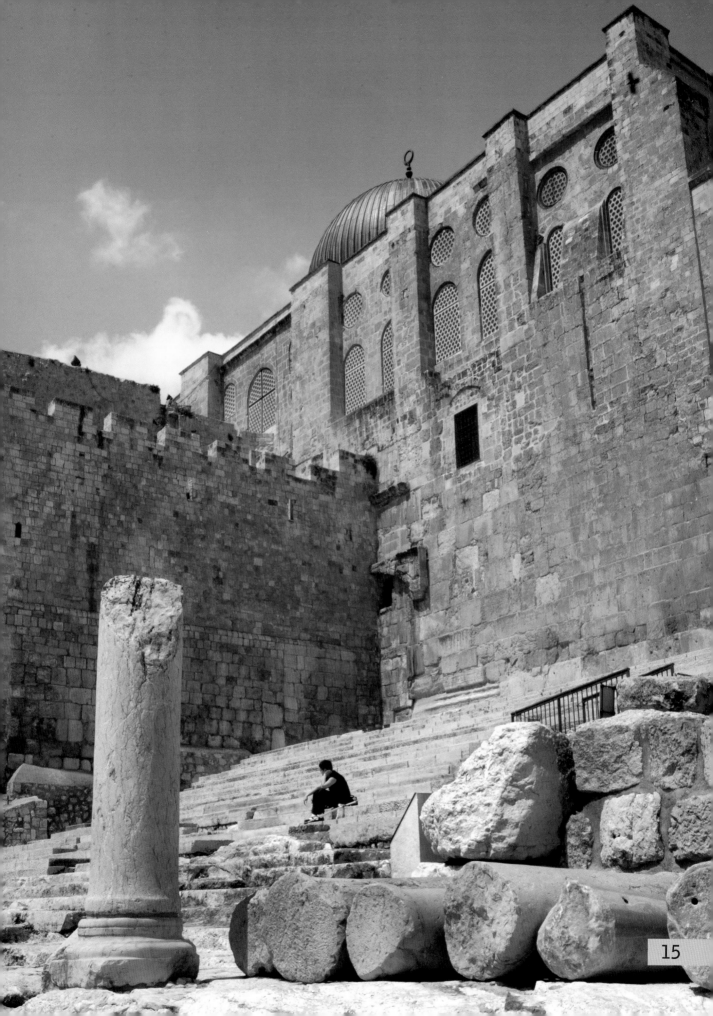

THE JEWISH QUARTER

Excavations in the Jewish Quarter have revealed untold treasures. Parts of the wide colonnaded street, the Cardo Maximus which was once the main thoroughfare of the Roman-Byzantine city, have been uncovered and incorporated into the modern structures which now stand on the original paving stones. Through special "wells" in the street, remains from the 1st Temple era and ramparts from the time of Jeremiah can be seen beneath. A replica of a mosaic map of sixth century Jerusalem found in Madaba, Jordan, in 1884 which portrays the colonnaded streets and buildings of the time can be seen at the beginning of the reconstructed Cardo. Remains of homes in the Upper City, the Burnt House, which contains relics of one of the priestly families and the Herodian mansion which were razed by the Romans in 70 C.E. reveal how Jews lived in Jerusalem until the destruction of the Second Temple. Jews were forbidden to live in Jerusalem until the Moslem conquest. Then, the Crusaders massacred the Jews and Moslems and only after the victory of Saladin in 1187, life for the Jews became easier though there were many ups and downs. Synagogues and centres of learning were built – and then destroyed once again during the Jordanian occupation of Jerusalem from 1948-1967. Today the Jewish Quarter contains reconstructed synagogues and yeshivot together with modern apartment buildings and houses. All are tastefully built around paved courtyards and well kept gardens – the old and the new blending together in a delightful fashion.

Part of the restored 6th century Cardo, now a shopping arcade mainly for tourists. In ancient times this was a much wider street. It continues north to Damascus Gate and forms the division between the Christian and Moslem Quarters. opposite: Aerial view of the Old City with the Jewish Quarter in the foreground. Insert: The Rothschild building.

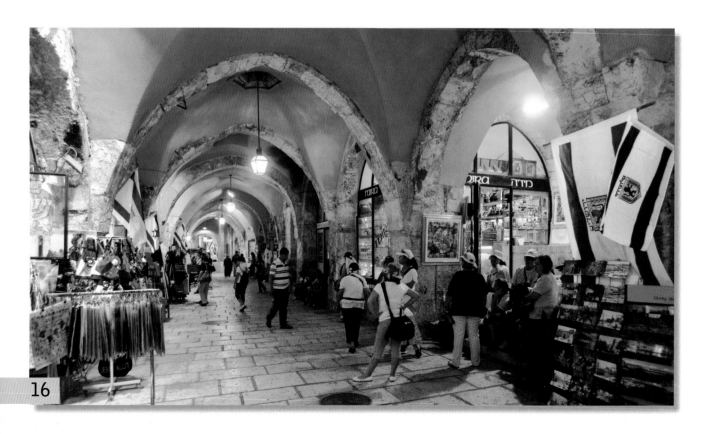

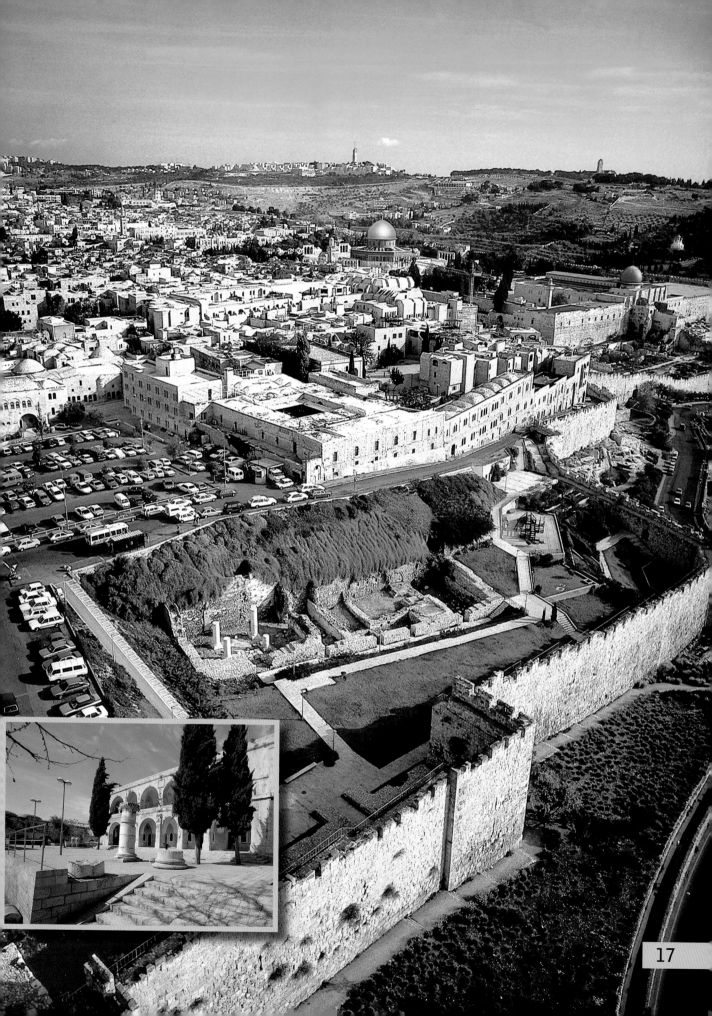

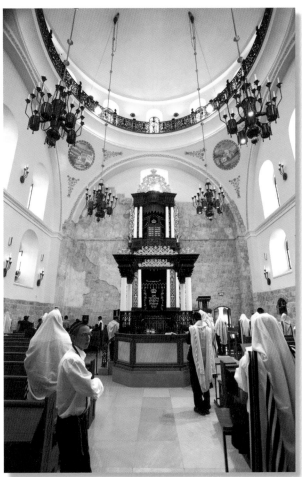

above and right: The restored Hurva synagogue which was destroyed in 1948 and reopened in 2010.
below: The excavated section of the Cardo. In the Byzantine era this colonnaded street linked important churches.

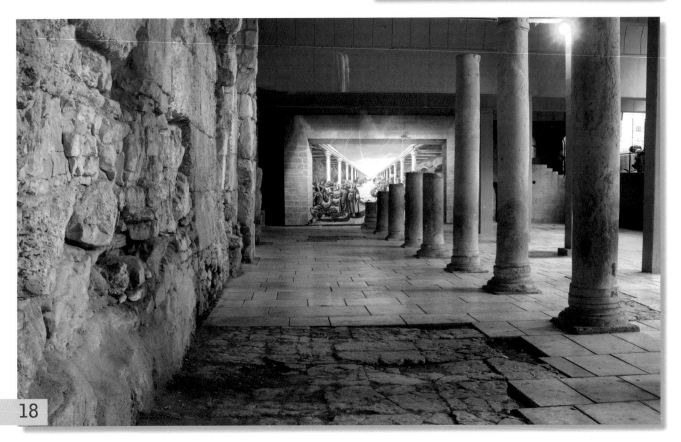

The Golden Menorah
The first seven-branched Menorah made since the destruction of the Temple, by the Temple Institute, Jerusalem. It was designed according to the specifications of the Bible and historical evidence (Donated by Vadim Rabinovitz).

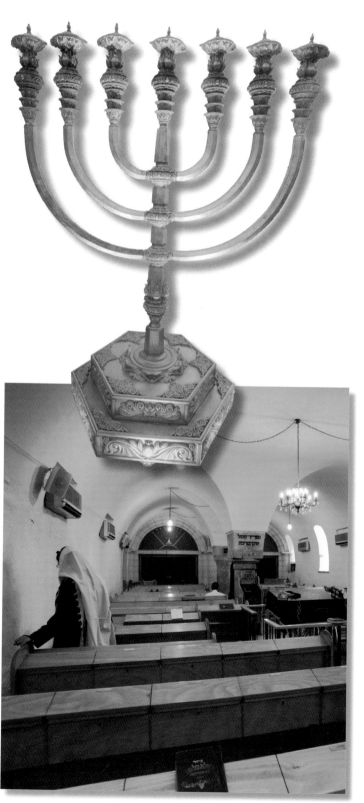

above: Remains of a magnificent 2nd Temple era Herodian mansion.
below: Seven-branched menorah carved on a wall in the mansion.
below left: Inside one of the restored Sephardi synagogues.

THE CITY OF DAVID

below: Road from the time of the Second Temple.
below left: Excavations in the City of David

Excavations on the site of David's city have brought to light part of the Jebusite ramparts of 4000 years ago, Israelite houses, palaces, ancient water systems and fortifications from the time of King David, as well as later walls and towers.

below: Part of the northern promenade pavement with its original stone floor. The wall illustration depicts the ambience of the Silwan Pool, which people walking here in Second Temple times would see (painted by Yael Kilemnik).

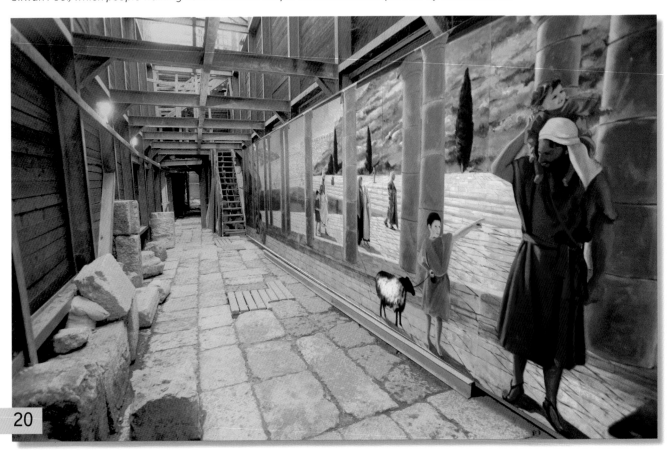

The Old City of Jerusalem with the City of David and the village of Silwan.

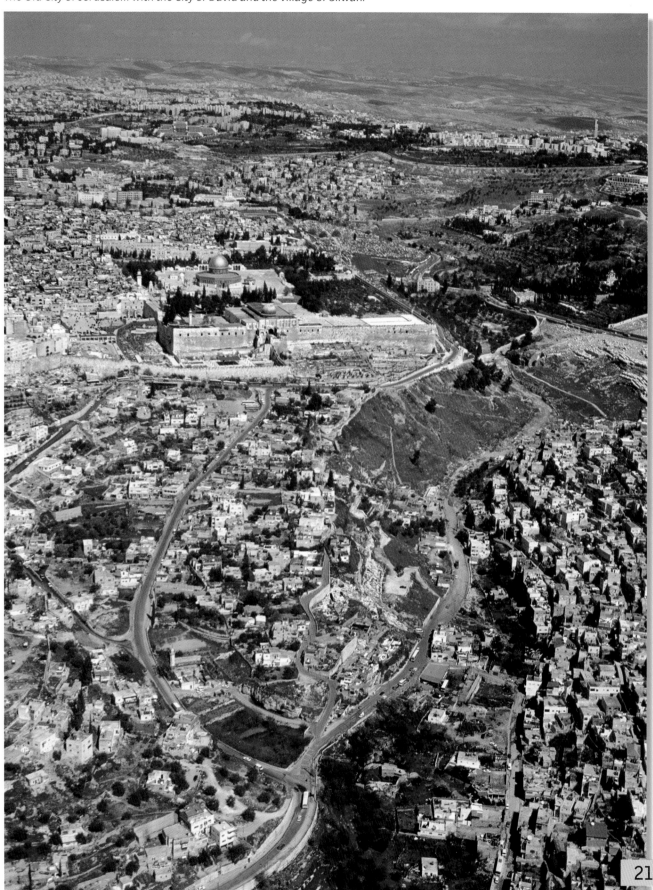

THE POOL OF SILWAN

Silwan (Siloam), just outside the Old City walls, runs along the Ophel down to the Kidron Valley. The Pool of Silwan receives water from the Spring of Gihon by way of Hezekiah's Tunnel. Since the sole source of water for Jerusalem was from this spring, it was imperative to conceal and divert the course in times of war. This was achieved in 701 BCE by King Hezekiah with such success that it was not until the 15th century that the residents of Jerusalem learned that the Pool of Silwan was not the actual water source.

right: Rock-cut interior of Hezekiah's Tunnel.
below: The Pool of Silwan.
below right: Warren's Shaft.
Insert: An 8th century inscription recording the construction of Hezekiah's Tunnel.

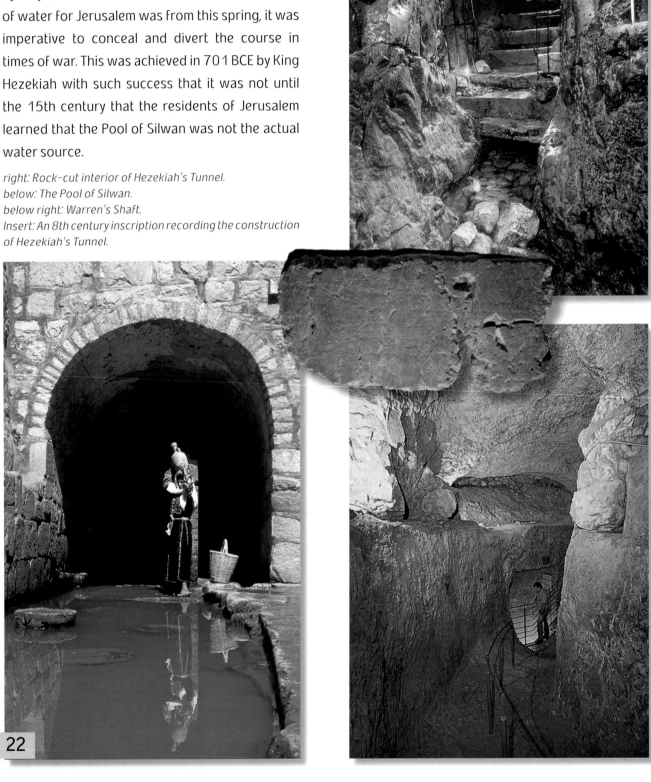

22

THE TEMPLE MOUNT

For the three major monotheistic religions, the Temple Mount is the historical and spiritual focus of Jerusalem. It is revered by Jews as the holiest place on earth – the rock at the centre of the Mount (now covered by the Dome of the Rock) is believed to be the place where Abraham prepared to sacrifice his son, Isaac. Solomon built the First Temple here, and later the Second Temple was erected on the same spot. Christianity associates the Temple Mount with the preaching of Jesus, whilst for Moslems this is the accepted place from which Mohammed ascended to heaven.

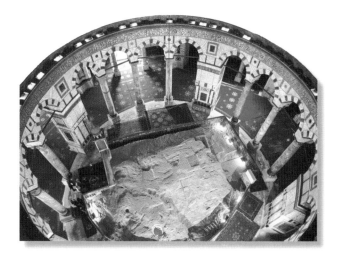

above: View of the Rock from which Moslems believe Mohammed ascended to heaven.
below: The Dome of the Rock.

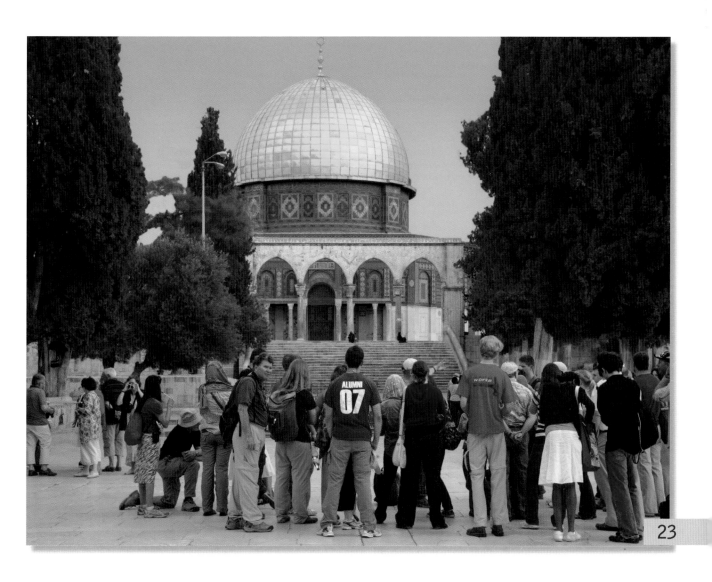

THE DOME OF THE ROCK

One of the wonders of the modern world, the gold-capped Dome of the Rock built by Ummayad Caliph Abd el-Malik in 691 is an outstanding landmark of Jerusalem. Wall mosaics, beautiful carpets and stained glass windows inside the mosque vie with the marble facade and blue and gold tiles on the outside walls of the building. Some of the numerous pillars may have been used in Herod's Temple.

right: The Golden Gate from inside the city wall.
below left: Beautiful decorations on the wall of the Dome of the Rock.
below right: Washing feet before entering Mosque.
bottom: The El Aksa Mosque

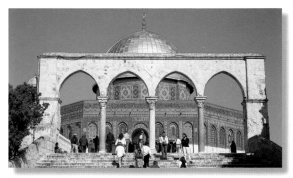

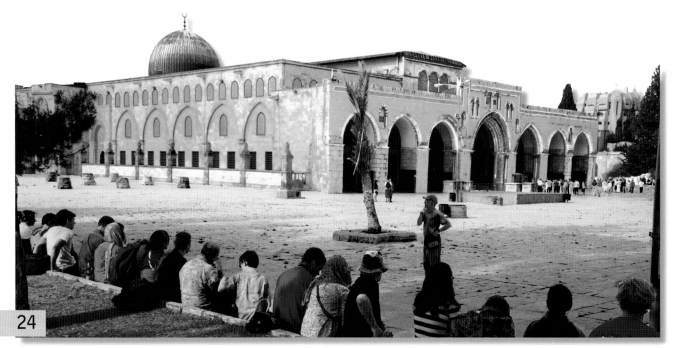

THE EL-AQSA MOSQUE

This mosque stands over an underground building called the Ancient Arcade. Built between 709-715 A.D. by Caliph Waleed, son of Abd el-Malik, the silver domed mosque is easily recognizable on the southern part of the Temple Mount. Exquisitely decorated pillars and arches support the roof; priceless rugs cover the floor. During the time of the Crusaders the mosque was used as a residence for the knights in charge of the Temple area. These knights became known as the Templars. Saladin restored the building to its original use as a mosque after the defeat of the Crusaders.

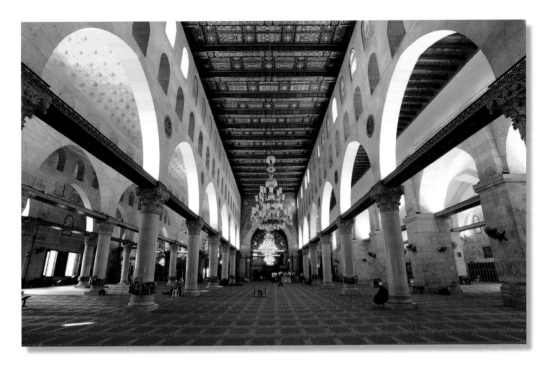

left: Interior of El Aksa Mosque, which marks the traditional site where Mohammed arrived in Jerusalem after his night journey from Mecca.

SOLOMON'S STABLES

Beneath the surface of the Temple Mount are huge vaulted halls which were constructed by Herod to support the platform and act as reservoirs. To the east of the El-Aqsa Mosque, a flight of steps in the paved courtyard leads to the underground vault known since Crusader times as Solomon's Stables. After their conquest of the city, the Crusaders kept their horses here. In 1996 it was converted into a mosque with a capacity for 7000 worshippers.

right: The mosque in the vault known as "Solomon's Stables".

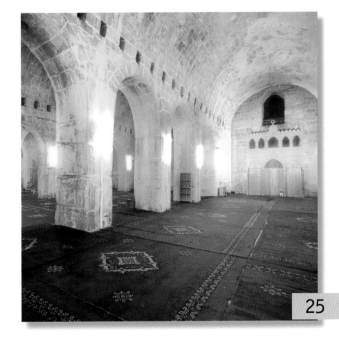

25

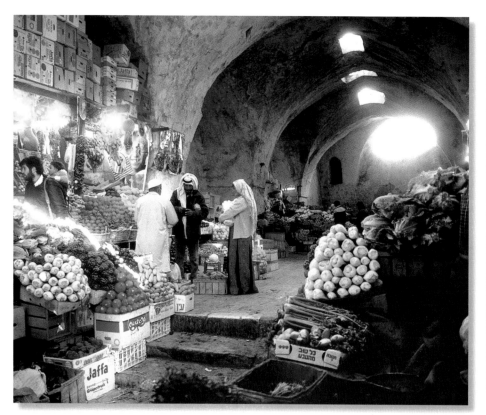

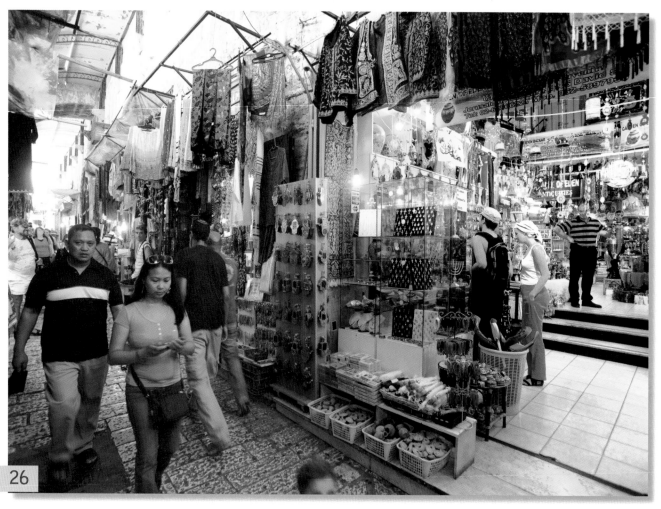

OLD CITY MARKETS

Visitors to Jerusalem are fascinated by the bazaars and markets of the Old City. There are unlimited possibilities for bargaining. The incredible array of spices, sweetmeats, fruits and vegetables all remind the tourist that the atmosphere of the Middle East is totally different to anything that he may have encountered "at home". Stalls and stores display antiques, pottery, jewellery, carved olive wood objects, embroidery and leather work. The list is endless – there is something to suit all tastes, and all pockets. Nobody needs to go away without a souvenir of his visit to Jerusalem.

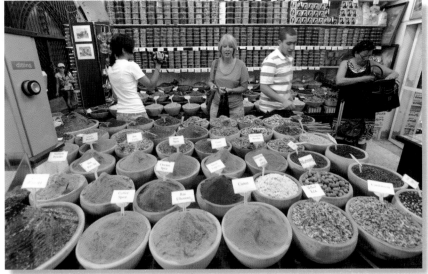

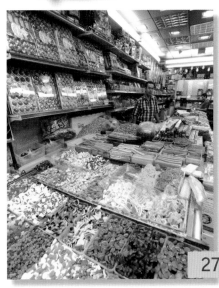

THE VIA DOLOROSA

The Via Dolorosa, the Way of the Cross, commemorates the path which Jesus walked bearing the cross from the Place of Judgement (Praetorium) to Calvary. Every Friday, groups of Christian pilgrims from around the world led by Franciscan monks retrace these steps, starting at the Church of the Flagellation and ending at the Church of the Holy Sepulcher.

There are fourteen stations along Christendom's most sacred route; each one marks an event that took place on the way to the Crucifixion. Nine of these points are actually along the Via Dolorosa, and five are inside the Church of the Holy Sepulcher.

above: The 1st Station, the Praetorium, in Antonia Fortress where Jesus was tried, today the courtyard of the Al-Omariya School
right: The 9th Station, an ancient column built into the door of the Coptic Patriarchate, where Jesus fell for the third time.
bottom right: The Lithostrotos in the Convent of the Sisters of Zion
insert: The "Kings' Game" scratched on a stone pavement, so called because of the engraved crown.

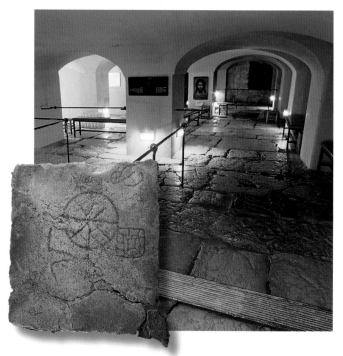

THE CHURCH OF ST ANNE

below: The Crusader Church of St. Anne near the Pool of Bethesda. The site is believed to be the birthplace of Anne, mother of Mary.

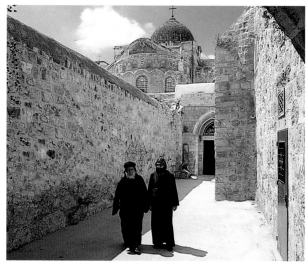

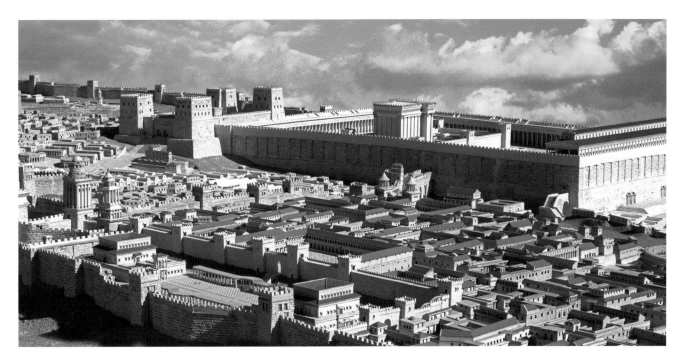

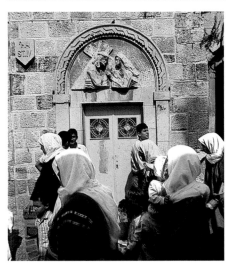

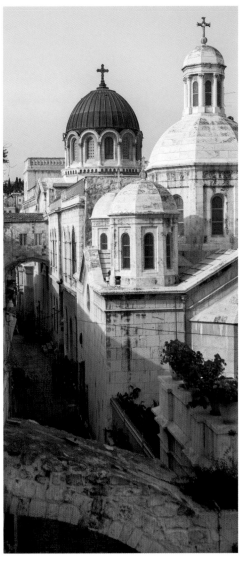

The Antonia Fortress was built by King Herod the Great on the site of an earlier Hasmonean citadel and named after his patron Mark Anthony. It was the main Roman garrison at the time of Jesus and according to tradition, he was tried and condemned here. Today the El-Omariya school is on the site and it is the starting point of the Via Dolorosa. The Fortress was destroyed by Titus' army in 70 CE.

clockwise from above left:
The 6th Station of the Cross, the Church of Veronica, built on the site of the house of Veronica who wiped Jesus's face with her veil.

The 2nd Station of the Cross.
The Franciscan Chapel of the Flagellation where Jesus was scourged.

The 4th Station, the Armenian-Catholic Church of Our Lady of the Spasm, with a bas-relief illustrating the meeting of Jesus and Mary. This event is not mentioned in the New Testament.

THE CHURCH OF THE HOLY SEPULCHER

Venerated by many Christians as their holiest shrine, the Church of the Holy Sepulcher terminates the way of the Via Dolorosa. It is believed that Jesus was crucified on this spot and buried here. In 325 C.E. the Emperor Constantine the Great ordered a church to be erected here after the location was revealed to his mother, the Empress Helena, in a dream while she was visiting Jerusalem.

Entrance to the Church of the Holy Sepulcher.

Three different buildings were erected – a round church, the Anastasis or Rotunda, above the empty grave of Jesus; a magnificent basilica, the Martyrium; and in the square between these two churches, a shrine marking the place of the crucifixion, named Calvarium (Golgotha). In 614 these buildings were destroyed by the Persians. They were later rebuilt, then destroyed once more in 1009 by Caliph Hakim. They were again partially restored until the Crusaders erected the present church in 1149 after their conquest of Jerusalem. Now the tomb of Jesus and the place of crucifixion are under one roof. The church is administered by several Christian communities in condominium.

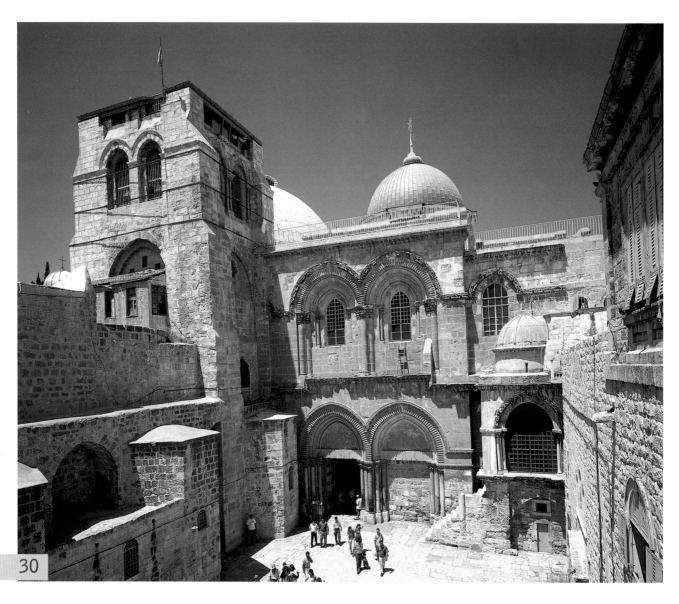

MOUNT OF OLIVES

The Mount of Olives is named for the olive trees that covered its slopes in ancient times.

The Mount holds an important place in Christianity. It was here that Jesus taught his disciples during his mission in Jerusalem; here he wept for Jerusalem and here he was betrayed by Judas and arrested.

The Church of all Nations, also called the Basilica of Agony, was built in the 1920's with contributions from 12 nations on ruins of Byzantine and Crusader churches. Its ornately decorated facade glinting in the sunlight, and the Garden of Gethsemane with its grove of ancient olive trees cared for today by the Franciscan Brotherhood are important holy sites for visitors. In front of the main altar of the Church is the traditional Rock of the Agony surrounded by a crown of thorns of wrought iron

The White Russian Orthodox onion-turreted Church of Mary Magdalene was built in 1888 by Czar Alexander III in memory of his mother, Empress Maria. The gold domes are typical of the Muscovite church style.

BETHANY

The village of Bethany, now known as El-Azariah, is famed as the place where Jesus performed the miracle of the raising of Lazarus four days after his death. A steep flight of steps leads to the tomb which is inside a cave. A minaret of a Moslem mosque today stands on the site of the cave.

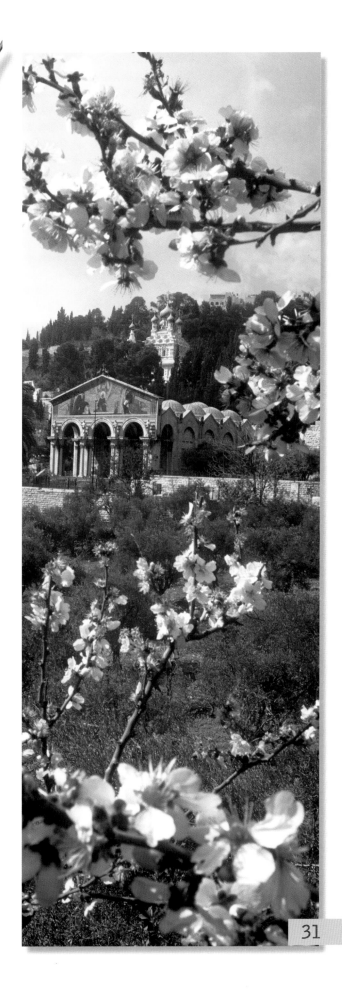

The Church of All Nations on the Mt. of Olives, with the White Russian Church of Mary Magdalene in the background.

below: Ancient graves in Kidron Valley – Absalom's Pillar, Tombs of Sons of Hezir, Zacharias' Tomb.
bottom: The Jewish cemetery on the Mount of Olives

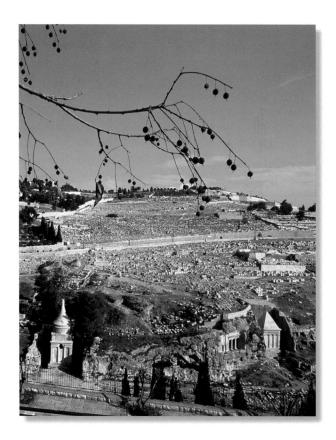

THE KIDRON VALLEY

Jewish tradition holds that the Messiah will come from the east, pass the Mount of Olives and continue through the Kidron Valley before arriving at the Temple Mount. All those who have died will rise on that day to escort the Messiah into the city. During the period of the First Temple, impressive burial chambers were carved into the rocks, testimony to the importance of the area. They can still be seen today.

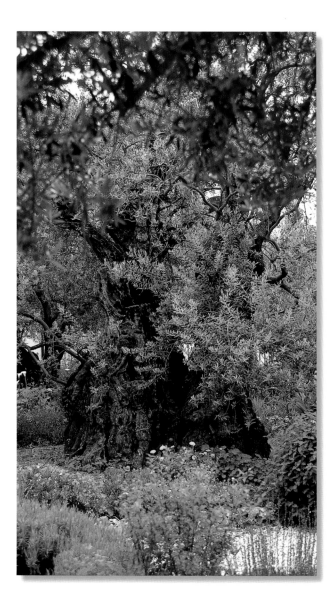

An ancient olive tree in the Garden of Gethsemane

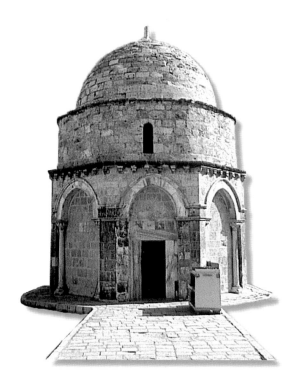

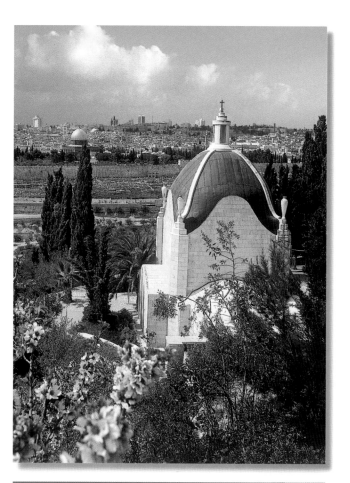

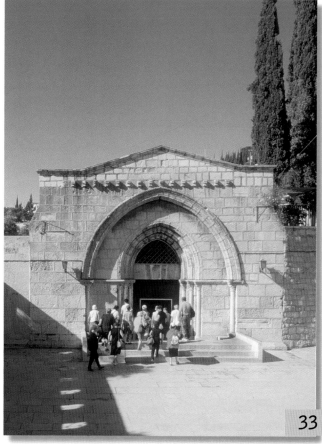

top: The Dome of the Ascension, where Jesus ascended to heaven.

above: The Church of Lazarus, Bethany, built in 1954 by the Italian architect Barluzzi, incorporating remains of earlier churches.

above right: Dominus Flevit Church, built in the shape of a tear on the site where Jesus wept as he foresaw the fate of Jerusalem.

right: The Greek Orthodox Church of the Tomb of the Virgin Mary where Mary was buried and taken up to heaven.

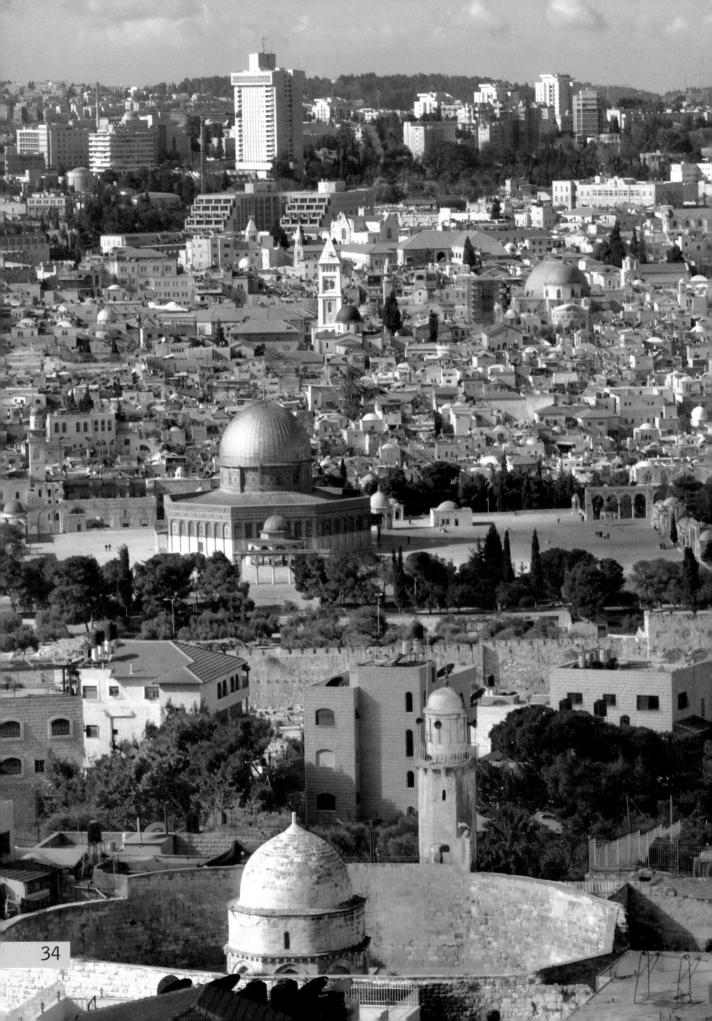

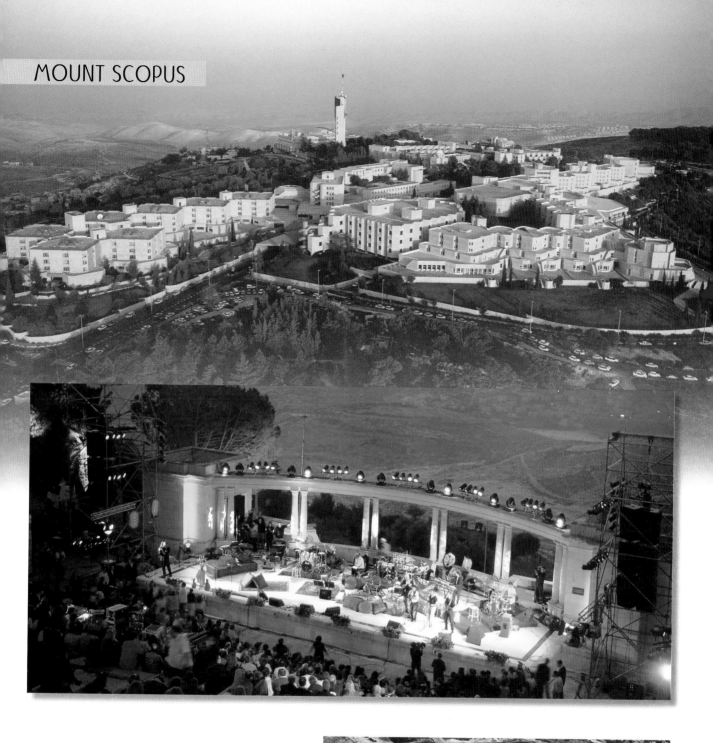

MOUNT SCOPUS

top: The Hebrew University campus on Mount Scopus.
center: The Hebrew University's amphitheater with the Judean Desert in the background.
right: Aerial view of the Hadassah Hospital campus on Mt. Scopus.
opposite: View of the Old City from the Mount of Olives with the golden Dome of the Rock in the center and Church of Ascension in the foreground.

THE GARDEN TOMB

The tranquillity and beauty of the grounds of the Garden Tomb make this site a truly meaningful place of pilgrimage for the many visitors who pass through its doors on a visit to the Holy Land. The site was discovered by a group of British Christians. Archaeological evidence of the two-roomed Herodian tomb, the huge, deep cistern, and the skull-shaped hill, as described in the New Testament, all led them to believe this to be the possible site of the crucifixion and the Resurrection of Jesus. The Garden Tomb Association, with headquarters in London, was founded in 1893. To this day the administration of the Garden Tomb is carried out by this evangelical foundation.

above: Golgotha, the Skull Hill
below: The ancient rock-hewn tomb

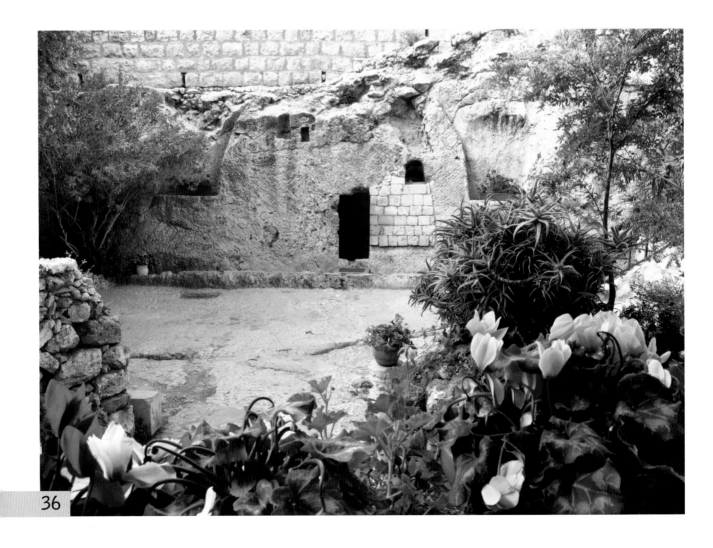

THE CHURCH OF ST. PETER IN GALLICANTU

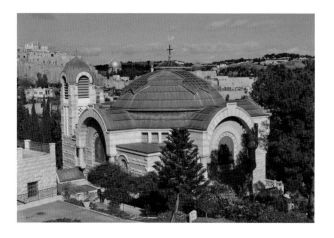

The church, built in 1931, stands on the accepted site of the House of Caiaphas, the High Priest at the time of the arrest of Jesus. Traditionally it is believed that this is the place where Peter denied his master. At the time of the Second Temple, steps in the courtyard of the Church of St. Peter in Gallicantu connected the City of David with the Upper City (Mt. Zion). This stairway can still be seen and excavations have revealed inscriptions and weights and measures of Second Temple times, as well as a rock-cut flagellation post.

MOUNT ZION

above: The Church of St. Peter in Gallicantu.
left: The ancient stairs leading to the Church were trodden by Jesus on his way to trial at the House of Caiphas.
bottom left to right: The Cenacle, Room of the Last Supper.
Tomb of King David.
View of Mt. Zion with the Dormition Abbey.

Mount Zion has always been an important point of interest for visitors to Jerusalem. Some of the shrines most sacred to Christianity and Judaism are to be found here. The black-coned roof of the Dormition Abbey stands out against the Jerusalem skyline. Traditionally it is believed that here Mary fell into eternal sleep. Close by is the Cenacle or Coenaculum - the Hall of the Last Supper. Jesus and his followers celebrated the Passover feast here. Beneath the Cenacle is the Hall of the Washing of the Feet, a small room which leads into a fair sized hall housing the Tomb of King David. Although this may not be the true grave, it nevertheless became a hallowed place for Jewish pilgrims between 1948 and 1967 when the Western Wall was in Jordanian hands and could not be visited by Jews.

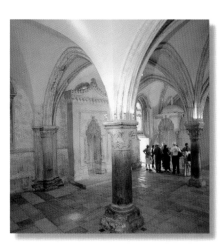

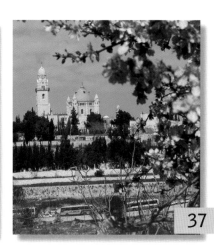

WEST JERUSALEM

Until the mid-nineteenth century, the 15,000 strong population of Jerusalem lived within the walls. The gates of the city were shut at dusk and only reopened at sunrise. Then, in 1860 Moses Montefiore built a windmill and a new neighborhood outside the walls which he called Mishkenot Sha'ananim, "peaceful habitations". This was followed by the establishment of other Jewish neighborhoods in the area that became known as West Jerusalem. The new city soon became Jerusalem's urban center, though up to 1967 was a quiet, provincial city on the fringes of Israeli economic activity. However, after the reunification of Jerusalem following the Six Day War, Jerusalem developed with unprecedented momentum and is still growing today. Restaurants, cafes and modern shops in street malls all combine to make "new Jerusalem" an exciting, busy city whose cosmopolitan atmosphere is unique. Important new buildings, constructed from Jerusalem stone, blend into their surroundings, whilst the well-kept parks and gardens play an important part in beautifying the city. Universities, synagogues, museums, libraries and galleries provide cultural stimulation. All offer a wide range of lectures, concerts and exhibitions on contemporary and classical themes to suit all ages and interests.

View of the neighborhood of Mishkenot Sha'ananim built in 1860 by Moses Montefiore. The windmill was intended to provide livelihood for the residents. The long building in the center is today a guesthouse for internationally acclaimed authors, artists and musicians visiting Israel, a convention center and home of the Jerusalem Music Center.

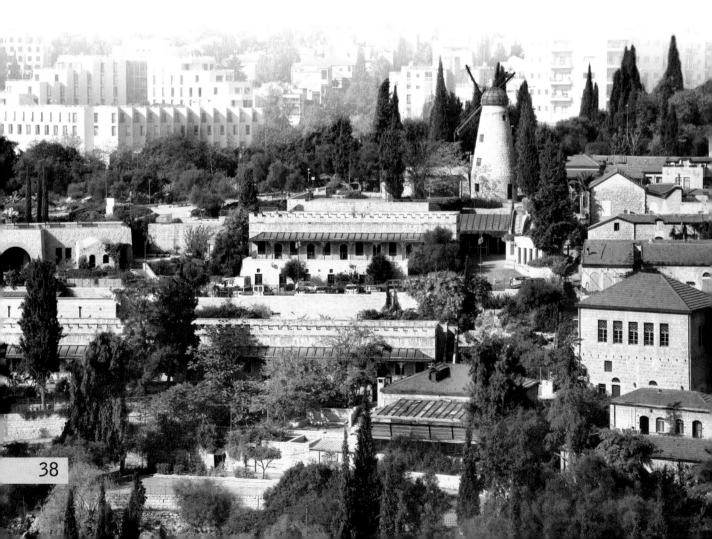

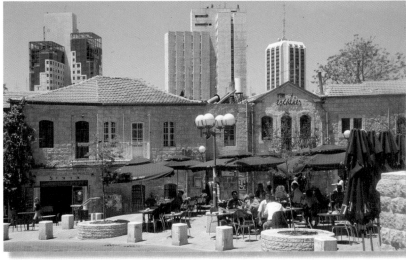

Clockwise from top left: The Jerusalem Chords Bridge designed by Santiago Calatrava for the light rail.

Downtown Jerusalem.

The Bible Lands Museum, which displays antiquities from the ancient lands mentioned in the Bible.

The Russian Compound, with the Russian Orthodox Church of the Holy Trinity, originally built to serve the many Russian pilgrims to Jerusalem.

Jerusalem Sherover Theatre.

Hechal Shlomo, seat of the Chief Rabbinate.

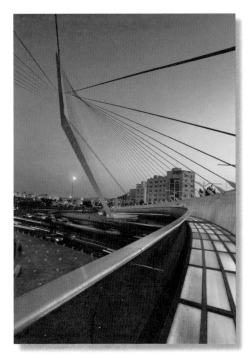

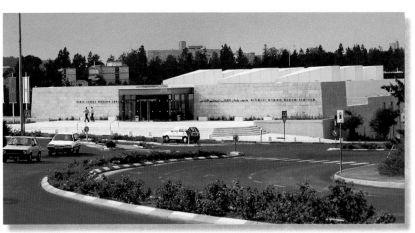

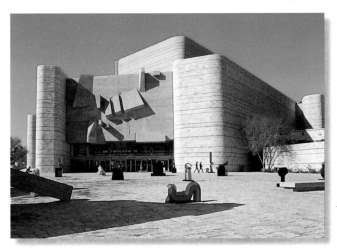

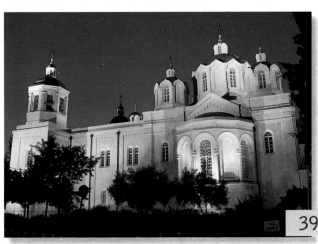

above: View of Mamilla. Originally established in the late 19th century as a business district, the newly renovated Mamilla opened in 2007, bridging between ancient and modern Jerusalem. The shopping avenue features many restored buildings with shops, restaurants and cafes.
above right: Ben Yehuda downtown pedestrian mall.
right: Malkha shopping center, the largest in Jerusalem.
below: The Jerusalem light rail.

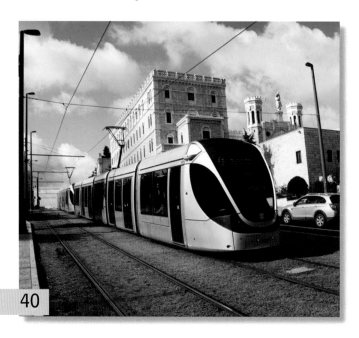

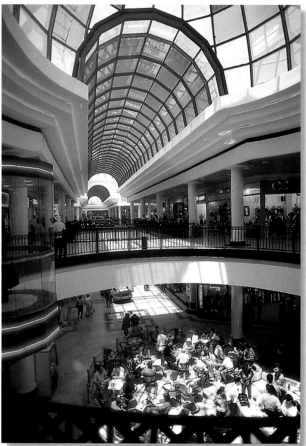

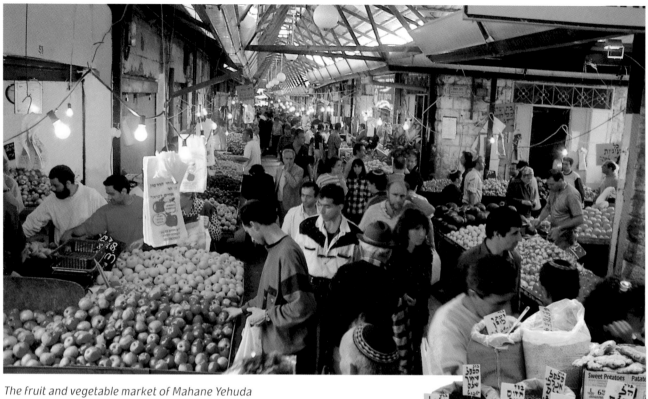

The fruit and vegetable market of Mahane Yehuda

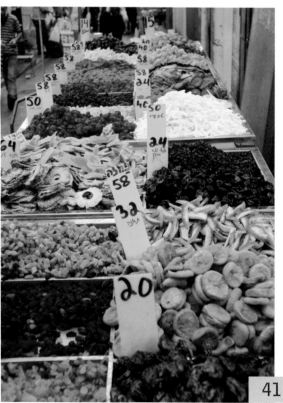

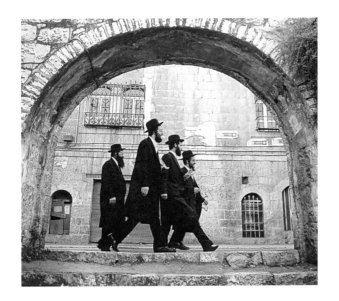

The seat of the Israeli Parliament, the Knesset, moved to its present location in 1966. Its sessions, three times a week, are open to the public. The long, low building of pink Jerusalem stone was designed by Joseph Klarwein and Dov Karmi. It contains many impressive works of art; three magnificent tapestries by Marc Chagall hang in the reception hall, and he also designed the floor and wall mosaics. Facilities for the one hundred and twenty Knesset members include a synagogue, reading and conference rooms, a library and restaurant.

Benno Elkan's menorah, which stands opposite the Knesset, was a gift from Britain to Israel. The menorah is modelled on the seven-branched candelabrum from the Temple which the Jewish exiles carried to Rome. Depicting twenty-nine images from Jewish life and history, it is the official emblem of the State of Israel.

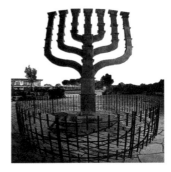

Views of Mea She'arim, a bastion of Jerusalem's ultra-Orthodox population. The neighborhood was founded in 1874 and today comprises many different groups, each with their own synagogue, yeshiva and ritual bath. Driving on the Sabbath is forbidden and visitors are requested to dress modestly.

below: Aerial view of the Knesset, meaning "assembly", named for the Jewish governing body of the early Second Temple Period.

left: The bronze Knesset Menorah.

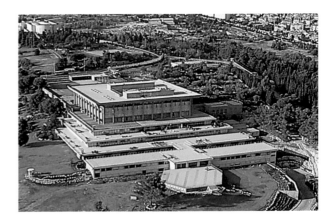

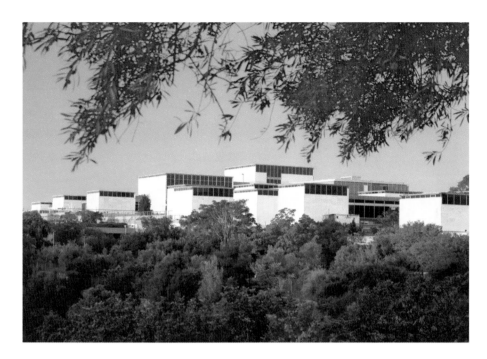

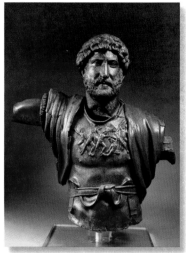

THE ISRAEL MUSEUM

The Israel Museum was originally opened in 1965 and was totally renovated in 2010. Sections are devoted to Judaica, archaeology, art and ethnic collections. The exhibits, both permanent and temporary, of drawings, paintings and sculpture of modern Israeli and international artists are constantly being updated and enlarged. There is a full program of lectures, concerts and films.

The youth wing is always filled with crowds of youngsters, all eager to learn and participate in the activities offered by this vibrant part of the museum.

below left to right: Suspense by Menashe Kadishman; Turning the World Upside Down by Anish Kapoor; Apple Core by Claes Oldenburg & Coosje van Bruggen.

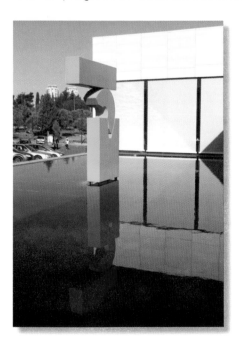

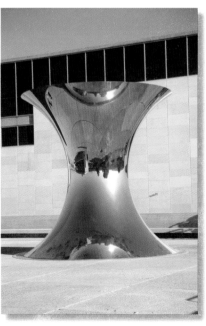

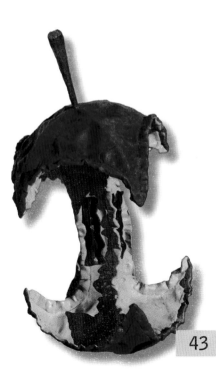

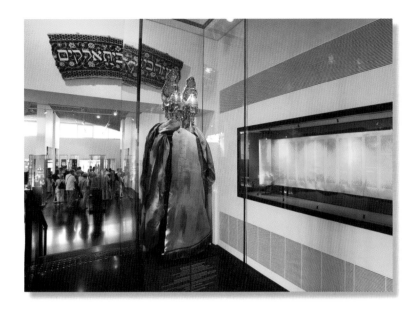

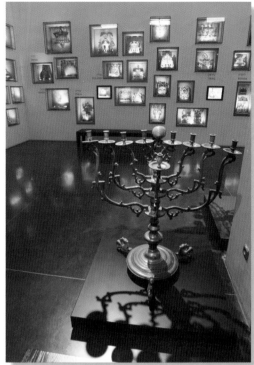

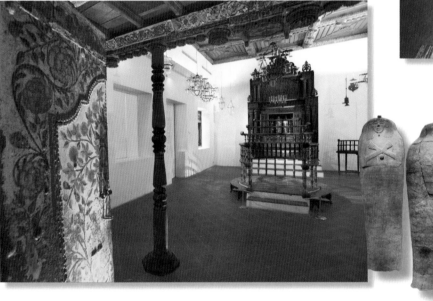

clockwise from top left: Jewish Ceremonial Art gallery; Menorahs from different communities all over the world; Ancient sarcophagi in the Archaeology Wing; Gallery in the Fine Arts Wing; The Kadavumbagam synagogue from Cochin, India.

THE SHRINE OF THE BOOK

The Shrine of the Book contains the priceless, oldest biblical manuscripts in existence, which were found in 1947 in caves at Qumran. A special building was erected to house the precious scrolls. Its domed white exterior resembles the lid of one of the earthenware jars in which the scrolls were hidden; this contrasts starkly with the wall of black basalt nearby. The shrine itself is subterranean, reminiscent of the caves in which the scrolls were found.

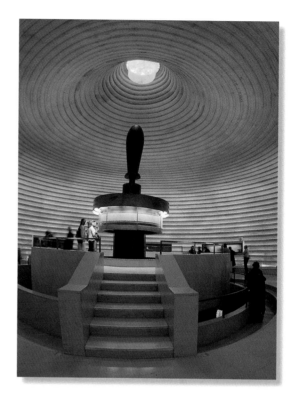

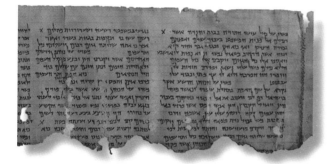

Interior of the Shrine of the Book.
left: A portion of the Isaiah Scroll displayed in the Shrine of the Book.

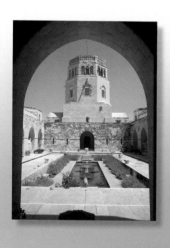

left: The Rockefeller Museum in East Jerusalem which houses a collection of Land of Israel antiquities.
below: The exterior of the Shrine of the Book. The white-domed shrine covers a structure that is two-thirds below the ground and is reflected in a pool of water surrounding it. The colors and shapes of the building are based on the imagery of the Scroll of the War of the Children of Light (the white dome) against the Children of Darkness (the black wall). In the background is the Knesset.

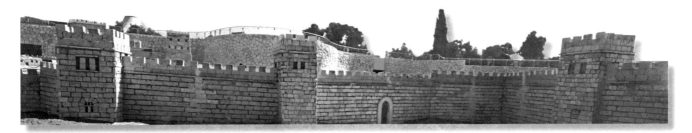

THE MODEL OF JERUSALEM AT THE TIME OF THE SECOND TEMPLE

The model, which today stands in the grounds of the Israel Museum, shows Jerusalem at the peak of its grandeur in 66 C.E. It depicts the Second Temple and the surrounding Jerusalem cityscape of the period; the topography and architecture of the ancient city have been meticulously recreated. Built to a scale of 1:50, it was constructed 1962–66 according to the measurements given in the Mishnah and the contemporary descriptions of Josephus Flavius. Wherever possible, authentic materials were used and when excavations revealed new information, changes were made in the model.

The magnificent Temple with its vast courtyard, Herod's Palace, the twin-spired palace of the Hasmoneans, markets, inns and homes are all identifiable.

clockwise from left: The western and southern walls of the Temple Mount, Herod's theater, the Temple, the Hasmonean Palace, Towers of Hippicus, Phasael and Mariamne, Antonia Fortress, Herod's Palace.

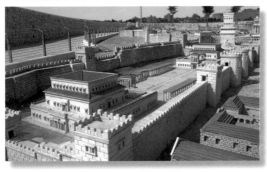

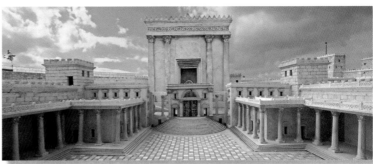

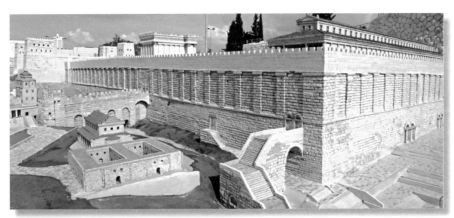

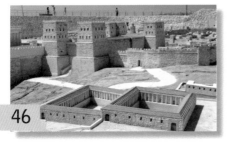

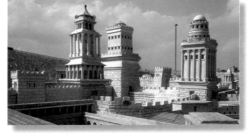

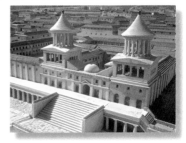

YAD VASHEM

The Martyrs' and Heroes' Remembrance Law – Yad Vashem, was passed by the Knesset in August 1953. Near to Mount Herzl, in west Jerusalem, an impressive complex was built to commemorate the 6 million victims of the Holocaust, and for documentation, research and education. The Hall of Remembrance with its Eternal Light is used regularly for ceremonies by visitors who come to pay their respects. The towering Pillar of Heroism honors the resistance fighters. The great blocks of stone in the Valley of the Destroyed Communities and the Children's Memorial pay silent homage to the millions who perished, whilst the quiet dignity of the Avenue of the Righteous Gentiles perpetuates the names of non-Jews who were imperilled trying to save their Jewish neighbors. The impressive new Holocaust History Museum presents the story of the Shoah, emphasizing the experiences of the individual victims through original artifacts, personal possessions and survivor testimonies.

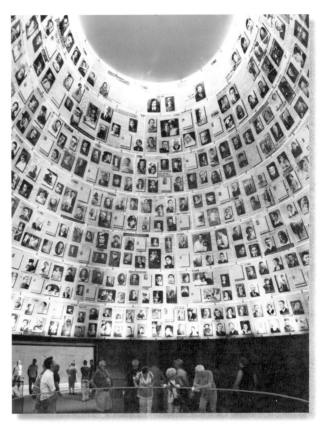

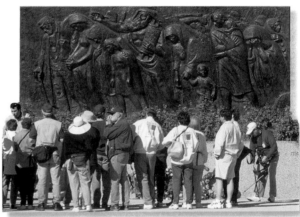

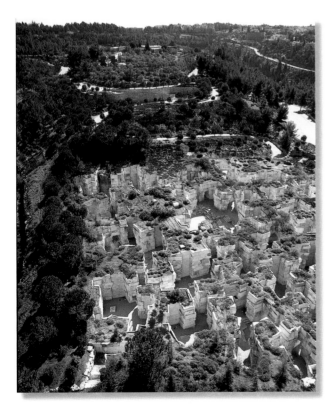

top: The Hall of Names
above: "The Last March" sculpture in Warsaw Ghetto Square.
below: Cattle Car Memorial to Deportees.
left: Aerial view of the Valley of the Communities.

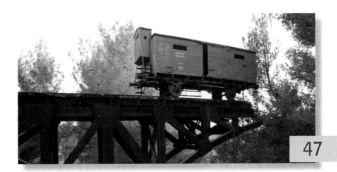

47

THE CHAGALL WINDOWS

In 1962 the French Jewish artist, Marc Chagall, presented to the synagogue of the Hadassah–Hebrew University Medical Centre in Ein Karem a set of magnificent stained glass windows. They represent the sons of the Patriarch Jacob from whom the twelve tribes of Israel were later descended. Each tribe has its own symbols – these are portrayed in magnificent colours on the twelve panels. We are told in Genesis 49 that Jacob blessed his sons before his death. Most of the subjects in the windows derive from that story.

from left to right:
top row – Dan, Joseph, Zebulun, Benjamin
center - Judah, Gad, Reuben, Naftali
bottom row - Issachar, Simeon, Levi, Asher

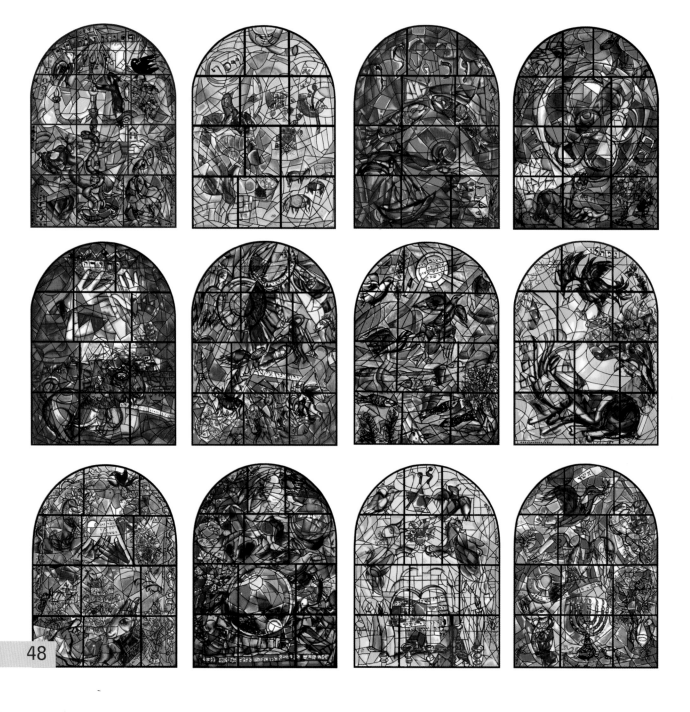

MOUNT HERZL

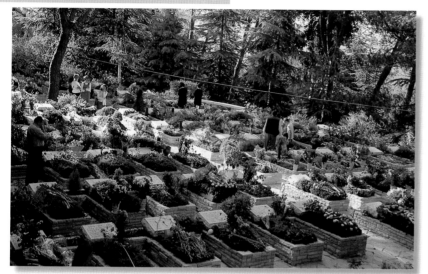

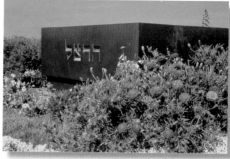

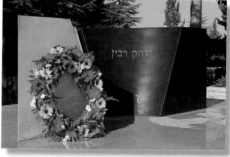

above: Military cemetery on Mount Herzl
above right: Herzl's grave
right: Yitzhak Rabin's grave

EIN KAREM

Christians identify Ein Karem ("the spring of the vineyard") as the home of John the Baptist "in the hill country of Judah" (Luke 1). Here Mary visited his mother, her cousin Elizabeth. The Church of St. John the Baptist marks his birthplace, and the Church of the Visitation overlooks the village. The spring, known as the Fount of the Virgin, still courses gently out of the mountainside.

below: General view of Ein Karem with the Russian Orthodox Monastery in the foreground and the Church of St. John the Baptist in the center.

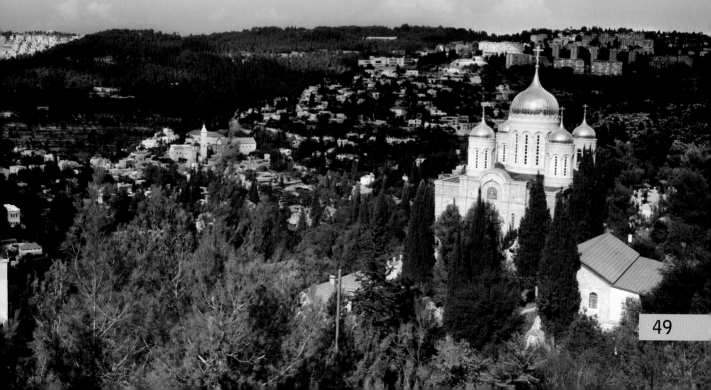

BETHLEHEM

Bethlehem is first mentioned in the Bible in Genesis 35:19 – "so Rachel died and she was buried on the way to Ephrath" (that is Bethlehem). The town is situated about 6 km south of Jerusalem in neatly terraced countryside. It was in the fields east of Bethlehem on a strip of arable land where wheat and barley have been raised since time immemorial that Ruth and Boaz met after Ruth arrived from Moab with her mother-in-law Naomi. Their union produced Jesse, father of David, who was born in Bethlehem and later was anointed as King of Israel by the prophet, Samuel. However, the event that made the town famous forever the world over was the birth of Jesus.

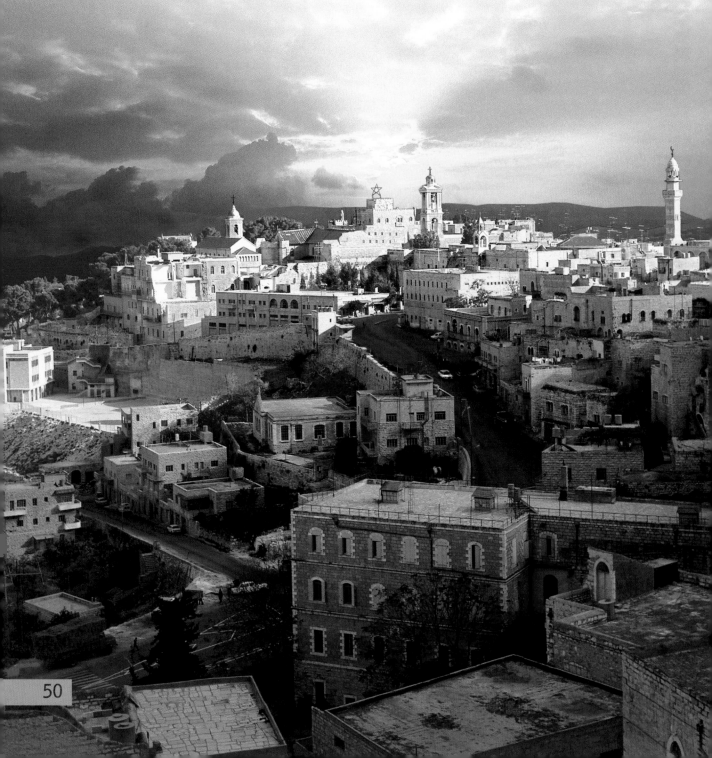

THE CHURCH OF THE NATIVITY

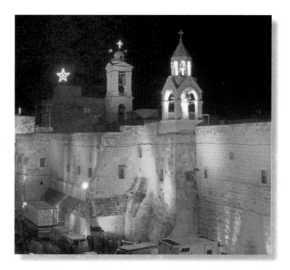

One of the holiest sites in Christianity is the manger in Bethlehem where Mary gave birth to Jesus. Helena, mother of Constantine the Byzantine emperor, built a church in 385 over the site and fragments of the mosaic floors of this edifice can still be seen. In 565, the Emperor Justinian erected the building as it stands today. The mosaics on the walls, the wax paintings on the columns and the decorations date back to the Crusader period. Some time during the seventh century, the doorway was lowered by partly sealing the Crusader arch to ensure that Muslims could not enter the church on horseback, so visitors must bend over almost double to gain access to the church. Most religious buildings were destroyed during the Persian invasion of the seventh century, but the Church of the Nativity was saved from desecration, according to legend because of the depiction of the Three Magi wearing Persian clothing. The site of the birth is marked by a 14-point star on a marble stone. The Church is administered jointly by Roman Catholics, Greek Orthodox and Armenians.

above left: Entrance to the Church of the Nativity.
center: The Church of the Nativity on Christmas Eve.
above right: The bells of Bethlehem.
below: Church of the Nativity with the Church of St. Catherine on the left.

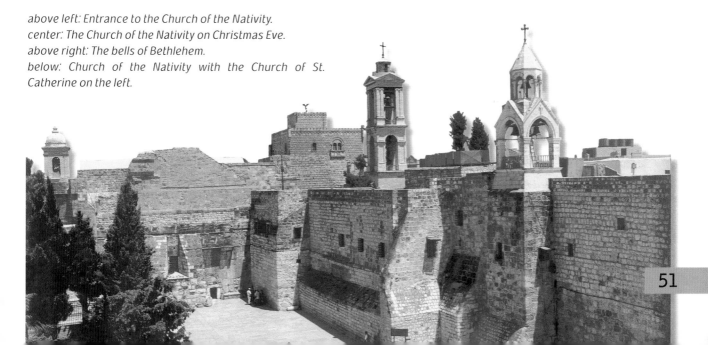

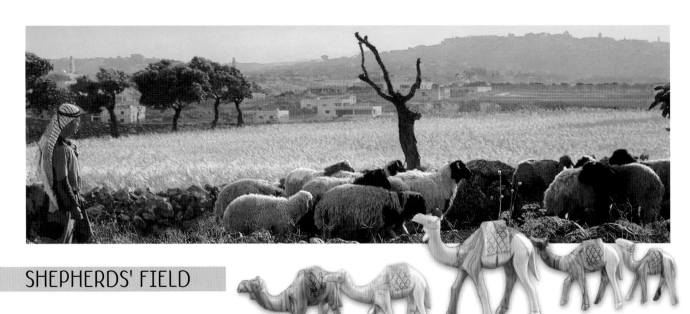

SHEPHERDS' FIELD

To this day shepherds take their flocks to graze in the fields around Bethlehem facing the hills of the Judean wilderness. The pastoral landscape has changed little since biblical times.

above: Shepherd's Field.
below left: Rachel's Tomb as depicted by William H. Bartlett, 1847.
below right: Praying inside Rachel's Tomb (photo:Rebecca Kowalsky)
opposite: Bethlehem market.

RACHEL'S TOMB

Rachel, Jacob's favourite wife, was buried "on the way to Ephrath which is Bethlehem" after she died giving birth to Benjamin (Genesis 35). She is the only biblical matriarch not buried in the family tomb in Hebron. Over the years Rachel's Tomb has become a place of pilgrimage for the Jewish people, especially childless women.

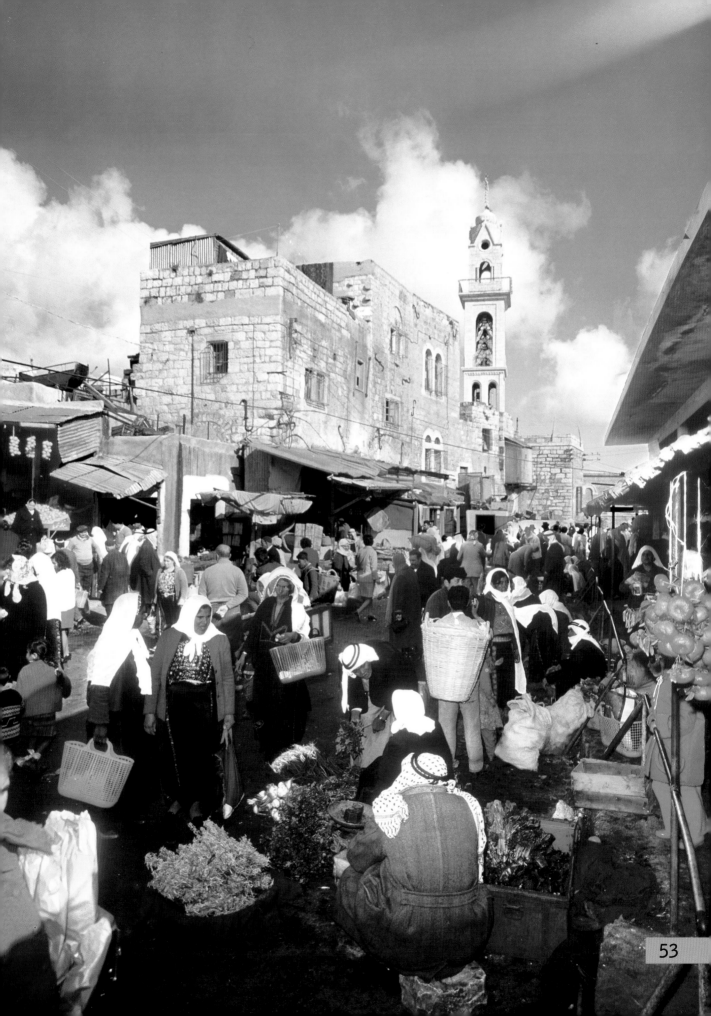

HERODIUM

Herod the Great built this fortification in the desert in 37 B.C.E. It stands like the crater of a volcano. In his book "Wars of the Jews" Josephus Flavius describes this astounding complex in detail: Herod "built round towers all about the top, and filled the remaining space with costly palaces He brought a mighty quantity of water from a great distance, and raised an ascent of two hundred steps of the whitest marble". Testifying to this description remains of magnificent buildings, colonnaded halls and walls painted with frescoes, can still be seen. A classical Roman bath house, one of the earliest synagogues ever found, and huge underground cisterns all helped to create one of the largest and most sumptuous compounds of the Roman Empire. Herod died in Jericho in 4 B.C.E and was buried in Herodium. His mausoleum was only discovered by archeologist Prof. Ehud Netzer in 2007, after a 35 year search. Subsequent excavations revealed more finds that suited Herod's status and taste,

above: The lower city of Herodium, at the foot of the hill.
below: The Byzantine chapel
bottom: Aerial view of Herodium. The arrow marks the location of King Herod's tomb.

confirming that this complex was designated as the crowning glory of his building career, that he chose to name for himself. Tragically, in 2010 near this spot, Netzer fell to his death.

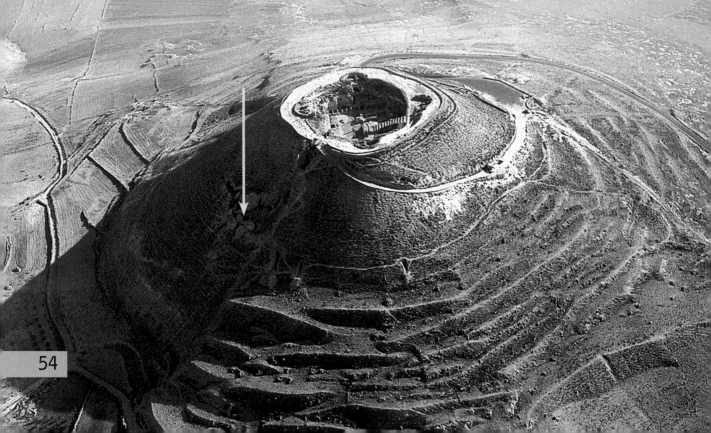

HEBRON

Hebron is one of the oldest and holiest cities in the Holy Land together with Jerusalem, Safed and Tiberias. It is home to the Tomb of the Patriarchs and was King David's capital before Jerusalem. It is also well known for its glass-blowing industry, and for the grapes, olives and figs that are grown on the terraced hills surrounding the town.

The Tomb of the Patriarchs is marked by a massive complex built by Herod the Great. Abraham bought the Cave of Machpelah from Ephron the Hittite to serve as a family tomb. Here he buried his wife Sarah and when he died he was interred close to her. Isaac and Rebecca and Jacob and Leah were buried here. According to legend, it was also the burial place of Adam and Eve.

Originally Herodian, the present structure was enlarged by the Crusaders and decorated by the Mameluks. Tombs were built over the graves as Moslems forbade entry into the cave itself. The hall is divided between Jews and Moslems - the larger, more ornate section serves as a mosque, while the smaller, more modest part is used as a synagogue. Visiting hours and times for prayer are also shared.

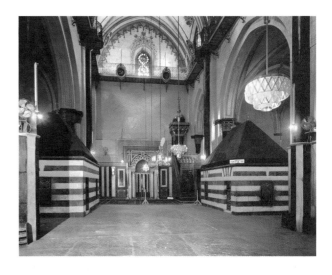

above: Cenotaphs marking the tombs of Isaac and Rebecca.
below: A potter and a glassblower.
overleaf: Aerial view of Hebron with the Tomb of the Patriarchs in the foreground.

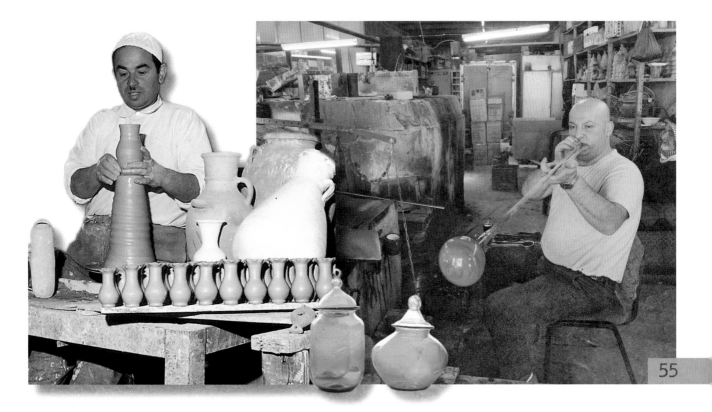

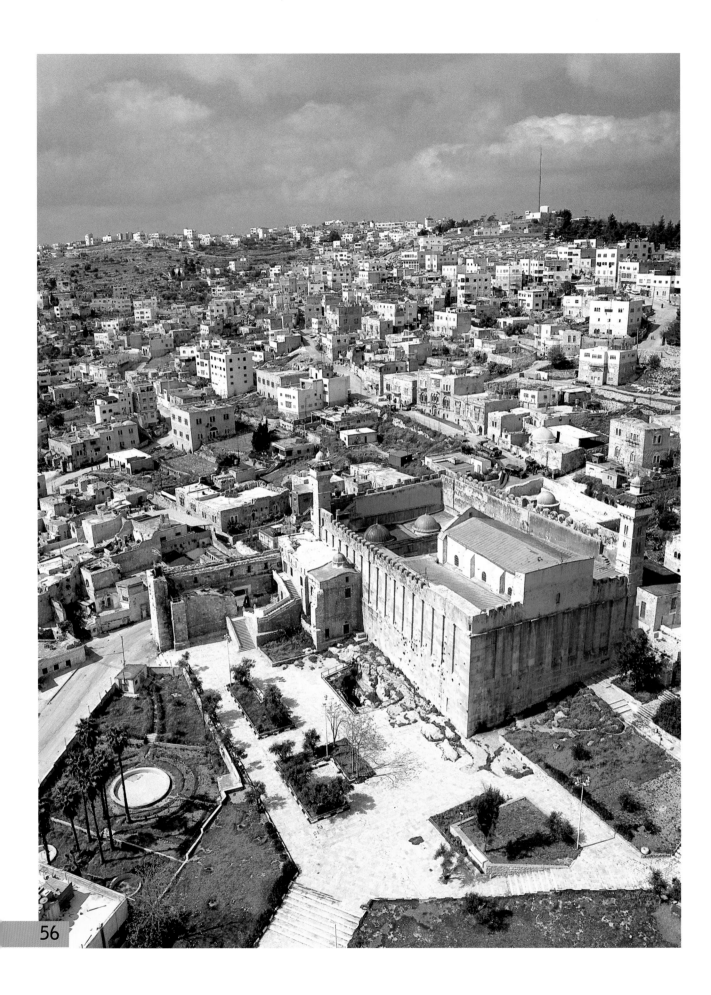

JERICHO

An evergreen oasis in the Jordan Valley, Jericho, known as the City of Date Palms, lies some 800 feet below sea level. It is thought to be the oldest continuously inhabited city in the world, dating back some 10,000 years.

Jericho was the first town conquered by Joshua after crossing the Jordan, though archaeologists have so far not discovered the ancient walls that he brought crashing down. From here Elijah,

above: The famous Hebron glass is still blown in the city today.
below: The Mount of Temptation
insert: Part of the mosaic floor from a 7th century synagogue in Jericho with inscription "Peace upon Israel".

accompanied by his disciple Elisha, was taken up to heaven in a fiery chariot after which Elisha "healed" Jericho's spring water by throwing salt into it. Among the most interesting finds at Tel Jericho is a monumental tower from the Neolithic period (7000 BCE) and remnants of a mosaic floor from a sixth century synagogue.

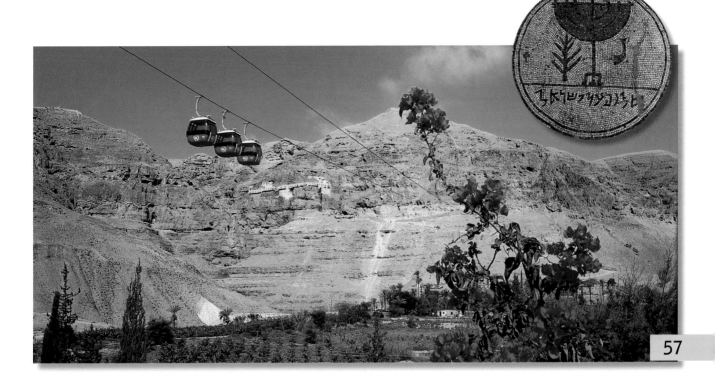

HISHAM'S PALACE

The Moslem Ummayad Caliph Hisham ibn Abd-el-Malik built a sumptuous winter palace north of Jericho during the eighth century, however it was destroyed by an earthquake four years later. The complex comprised a two-storied palace with a courtyard, a mosque and bath house which was also a banqueting hall. Some of the exquisite mosaics and stucco decorations are still preserved and carved stone remains give some idea of how impressive the palace must have been.

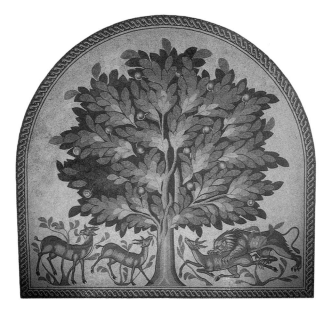

above: 8th century mosaic from Hisham's Palace depicting a pomegranate tree and a lion attacking a deer.

left: Remains of Hisham's Palace with carved stone decorations.
below: General view of the ruins.
insert: Knot window
opposite page: Tel Jericho, showing the round Neolithic tower dating to around 7000 BCE.

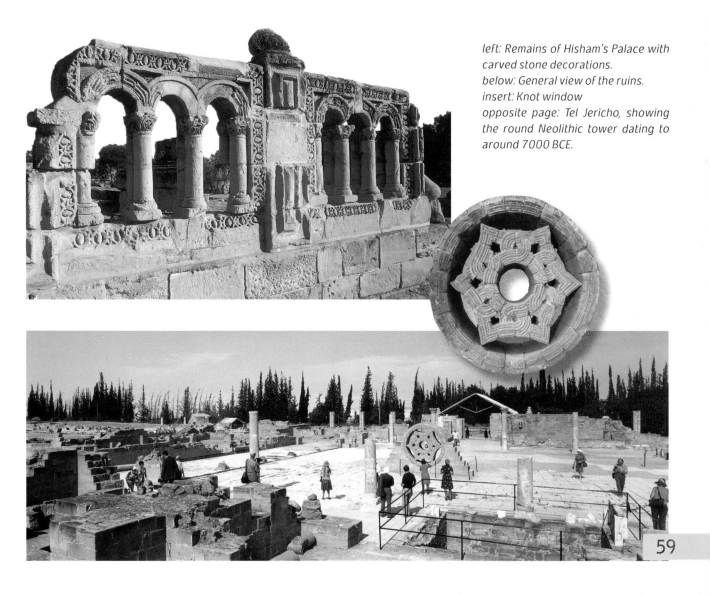

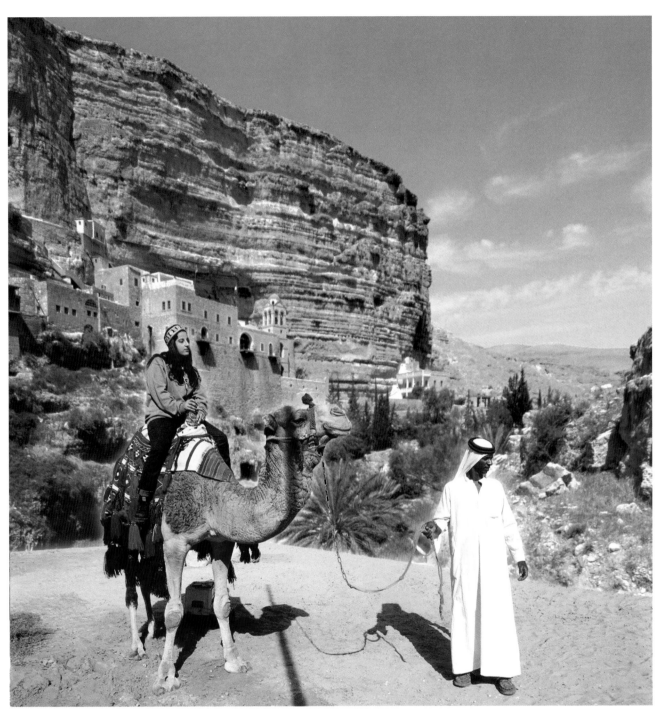

above: St. George's Monastery in Wadi Kelt.
left: Numerous mountain springs reach Jericho via aqueducts, both ancient and modern.
right: Jericho is famous for its citrus fruit and bananas.

THE JUDEAN DESERT

right: Palm plantations near Qumran.
center: A herd of ibex on the shores of the Dead Sea.
below left: Snappling in the Judean Desert.
below right: On the way down to the Dead Sea, the lowest spot on earth.

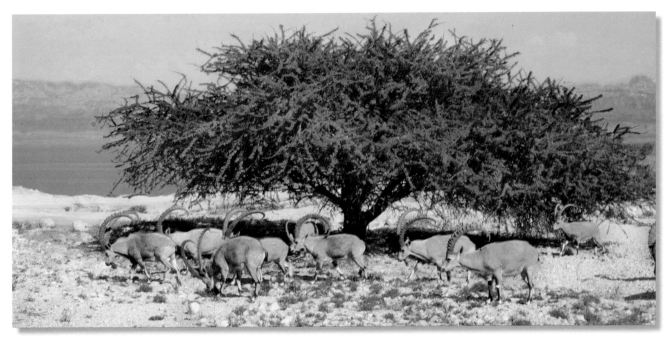

QUMRAN

The most stunning biblical archaeological find took place in 1947, when a young Bedouin shepherd boy unknowingly discovered a hoard of ancient manuscripts, the Dead Sea Scrolls, high up in a cave at Qumran on the western shore of the Dead Sea.

Archaeologists have excavated a large assembly hall, dining room, kitchens, laundry, a potters' kiln, cisterns and a cemetery. The vast scriptorium bears evidence of the scribes' work – transcribing texts from the Bible and other works written during

below: The Manual of Discipline Scroll and an inkpot discovered in Qumran.
Bottom: Bird's eye view of Qumran.

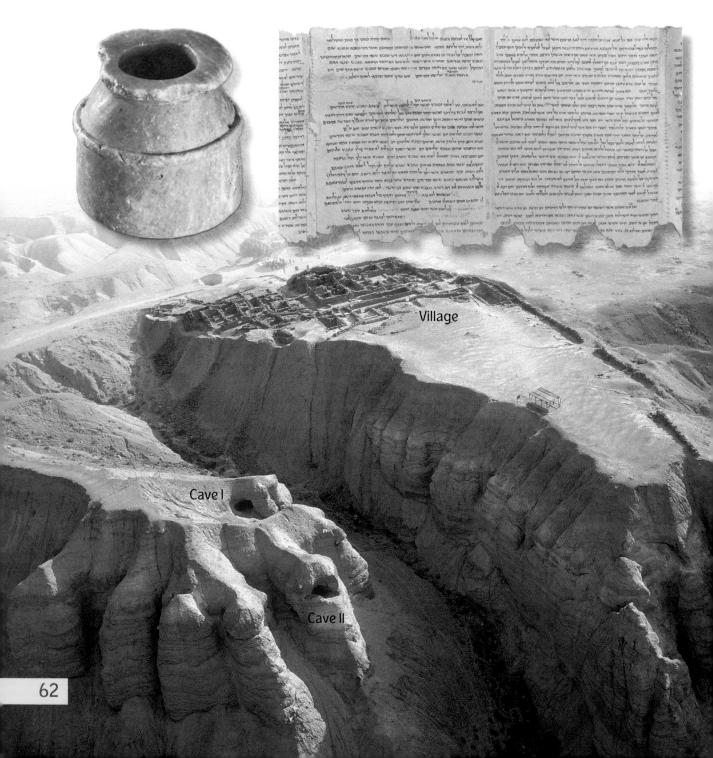

Village

Cave I

Cave II

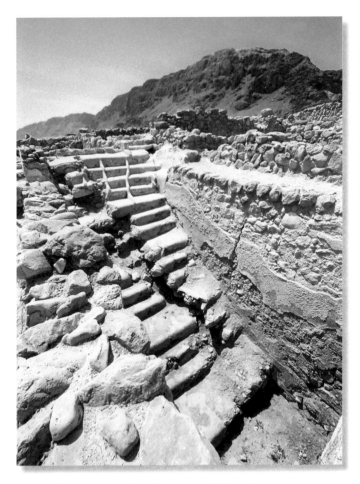

the Second Temple era on leather, papyrus and copper. Some of the scrolls contain the oldest existing Old Testament texts. When Titus and the Roman legions arrived at Jericho, the Essenes, as the sect was known, fled, hiding their scrolls in jars in the nearby caves. The desert kept their secret for almost 2,000 years. The discovery of the scrolls had an enormous effect on the Christian world as they were transcribed at the time of the birth of Christianity. The scrolls are now housed in the Shrine of the Book at the Israel Museum in Jerusalem.

above: Stairs to one of the ritual pools (Mikveh).
top right: View of the excavations.
below: Interior of caves and clay jar in which scrolls were found.

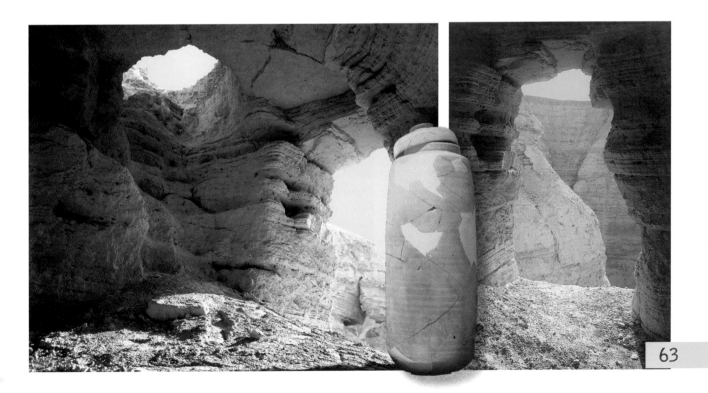

EIN GEDI

The biblical oasis of Ein Gedi lies near the shores of the Dead Sea. It was one of the desert settlements of the Tribe of Judah. David fled from King Saul's wrath to Ein Gedi. At the time of King Solomon it was renowned for its balsam cosmetics made with secret recipes. Famous for its springs and waterfalls the lush tropical vegetation is the perfect setting for the ibex and occasional leopard that still roam freely in this beautiful nature reserve. Kibbutz Ein Gedi, established in 1949, has developed into a holiday and study center and tourism and the growing of dates provide employment for its members. During the Roman-Byzantine era, Ein Gedi was a prosperous town, as attested to by the mosaic floor of the synagogue. The nearby spa of Hamei Ein Gedi is famous for its thermo-mineral waters which have unique properties. For those with more sophisticated tastes there are hotels of all grades further along the sea shore at Ein Bokek.

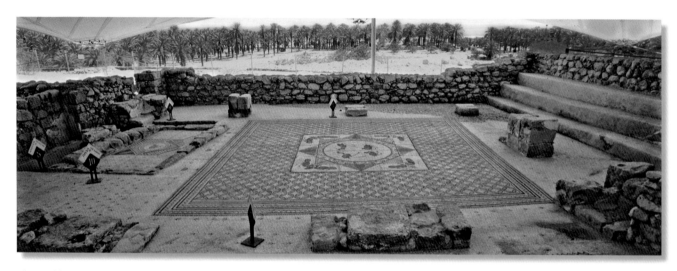

above: Mosaic discovered in the ancient synagogue of Ein Gedi.
Below: Spotted leopards are now almost extinct in the area.
Ibex at a pool at Ein Gedi waterfalls.

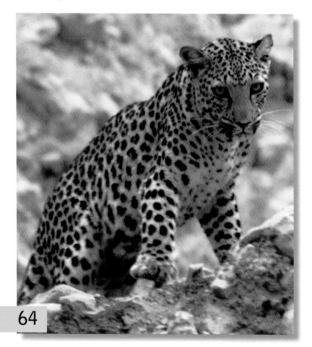

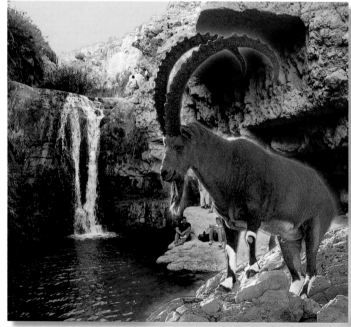

SODOM

Sodom, at the southern tip of the Dead Sea, is associated with the Biblical story of Lot (Genesis 19:24). Fleeing to Zoar from the doomed city of Sodom, Lot and his wife were warned not to look back to the city which was to be destroyed by fire and brimstone because of the wickedness of its people. Lot's wife disobeyed and was turned into a pillar of salt. On the slopes of Mount Sodom there stands to this day a pillar of salt which, with a little imagination, could well be Lot's wife.

The grey salt rocks and canyons of the Sodom region are indeed barren and cursed.

above: ATV vehicles touring Zoar Citadel in the Dead Sea area.
below: Snappling at Mount Sodom.

MASADA

The first century BCE Hasmonean rulers first chose this wide, 1300 feet high plateau overlooking the Dead Sea as a hideout. However, it was Herod the Great who turned it into a unique fortress to serve him when in mortal danger with all the luxury he was accustomed to.

In 40 BCE, Herod fled from Jerusalem, taking refuge with his wife and family at Masada. Leaving them there he continued on his journey to Egypt, finally reaching Rome. Appointed king of Judea he returned to Masada together with two Roman legions and built himself huge palaces with ornate bathhouses, wonderful mosaic floors and magnificently decorated walls, massive cisterns, storehouses and servants' quarters. Due to the dry conditions, these have been well-preserved.

Masada became an armed Jewish encampment when it was taken over by revolutionaries known as the Sicarii (or Zealots) who had fled from Jerusalem after its fall in 70 CE. Taking refuge atop Masada they banded together using the fortress as a base of operations against the Roman army.

right: Part of King Herod's northern palace.
below: The rock of Masada stands out in the desert scenery.
iopposite: Aerial view of Masada showing the excavations, the three-tiered northern palace and a pile of catapult stones.

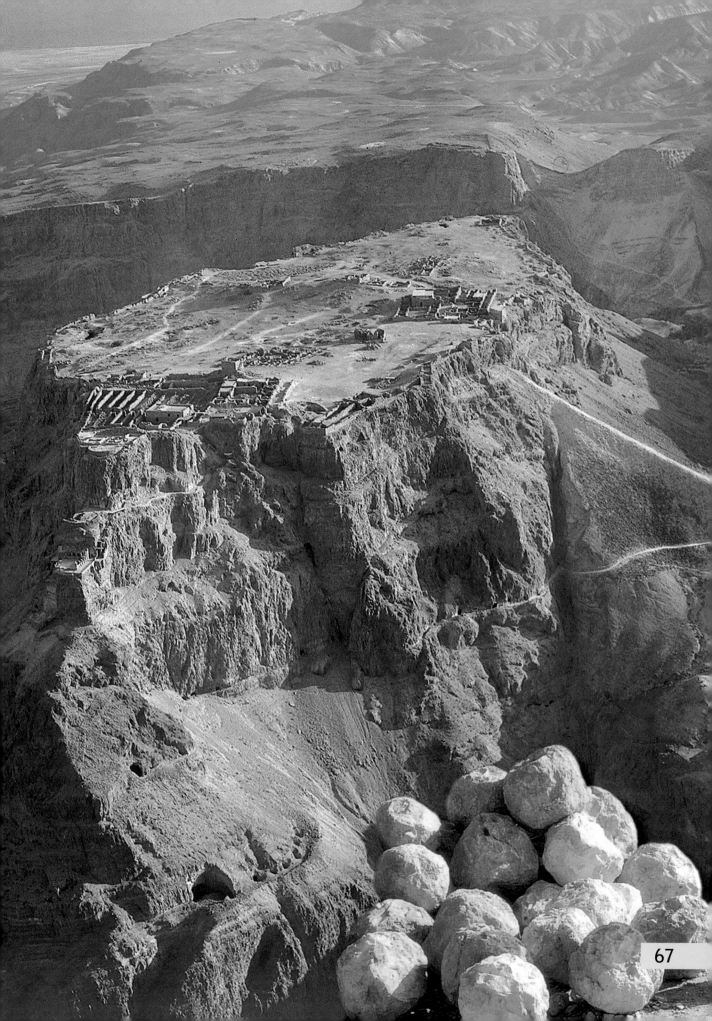

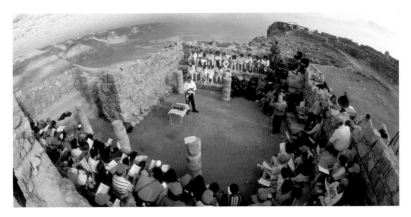

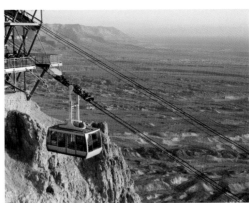

In 73 CE, the Tenth Roman Legion started to attack this final Jewish stronghold, building camps and a huge earthen ramp. Josephus Flavius describes the moving events in his "The Wars of the Jews". The zealots held out for another year, however when the Romans were about to break into the fortress, they chose to commit mass suicide rather than be captured by their enemy. Each father put his own wife and children to death with his sword and the men then drew lots till all had been killed. Masada soon fell into disuse, though it was inhabited for a short while by Byzantine monks during the fifth century.

Deserted once more Masada remained silent and unused until excavated in 1963. Today it is the venue for the solemn swearing-in ceremony of soldiers from one of Israel's elite armoured units who declare "Masada shall not fall again!"

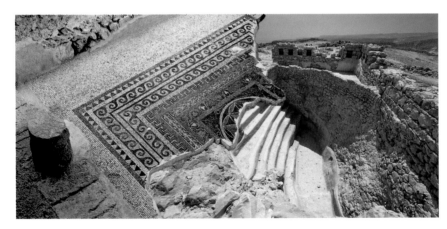

above left: A Bar Mitzvah in the synagogue.
above right: The cable-car at Masada
left: Part of the mosaic in the bathhouse of the western palace.
below left to right: Pool built by the Zealots in Herod's bathhouse where remains of the original plaster have been preserved; Caldarium; Water cistern.

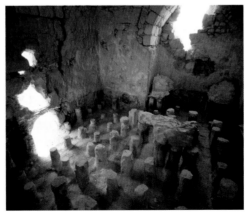

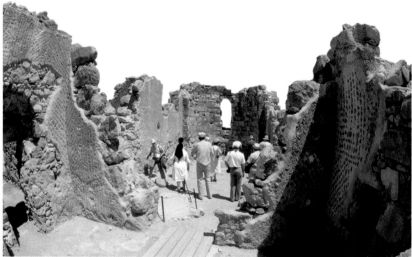

clockwise from top left: Byzantine church; the Snake Path; The western palace; Sound and Light on Masada.

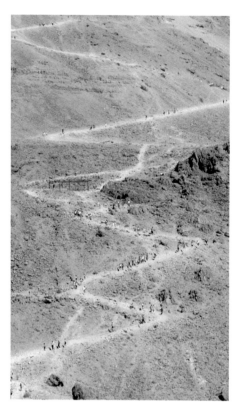

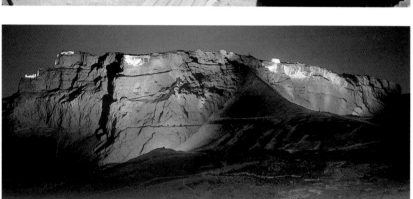

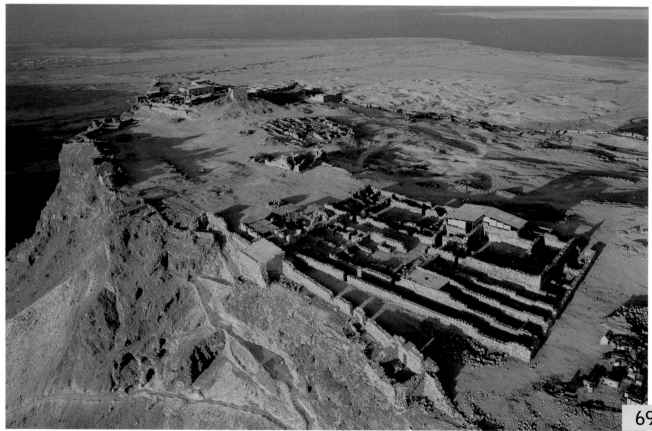

THE DEAD SEA

The Dead Sea is the lowest spot on earth, 1290 feet below sea level. Containing 30% of magnesium, sodium, calcium, potassium chloride and other salts, it has the highest mineral content of any body of water in the world. These minerals are extracted and refined at the Dead Sea Works and used for agricultural and industrial purposes. Mounds of crystallized salt formations dot the shoreline, looming out of the water like eerie sentinels. Until recently, when an alga was identified in its waters, it was thought that no living thing could survive here, hence the name. The book of Genesis describes it as the Salt Sea.

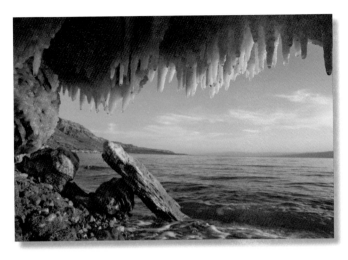

above right: Stalactite salt formations at the Dead Sea.
right: The mud found on the banks of the Dead Sea contains a high concentration of minerals which have curative powers especially for skin.
below: Hotels on the shores of the Dead Sea where people from all over the world come to take cures for skin and other diseases, and to enjoy the sun.
opposite left: Salt crystal formations.
opposite right: Floating on the Dead Sea
opposite below: Sunrise over the Dead Sea

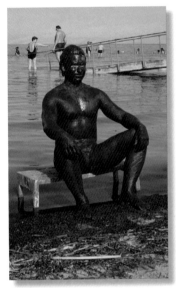

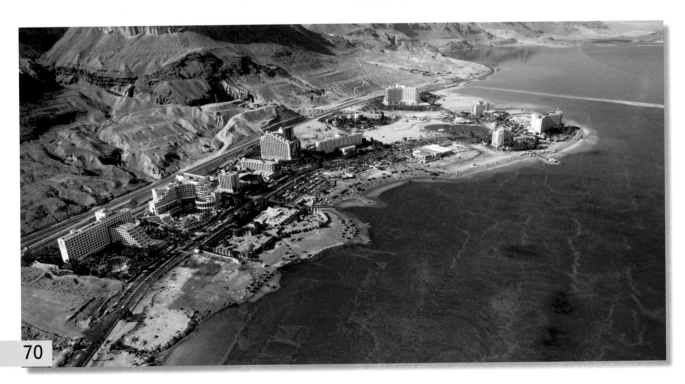

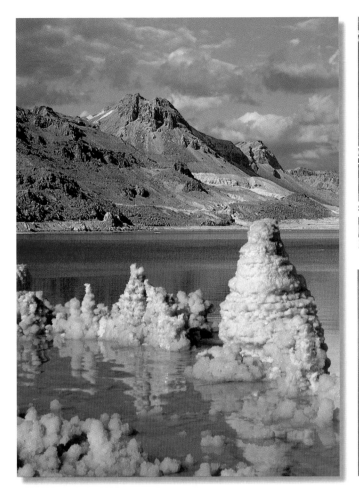

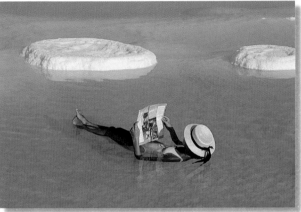

The black mud found in vast quantities has scientifically recognized curative qualities. Bathing in the natural sulphur pools, or just floating on the oily water are helpful to people suffering from skin diseases or muscular problems. Along the southern segment are located excellent hotels and well-equipped spas where visitors can bask in the sun and enjoy the curative powers of the water.

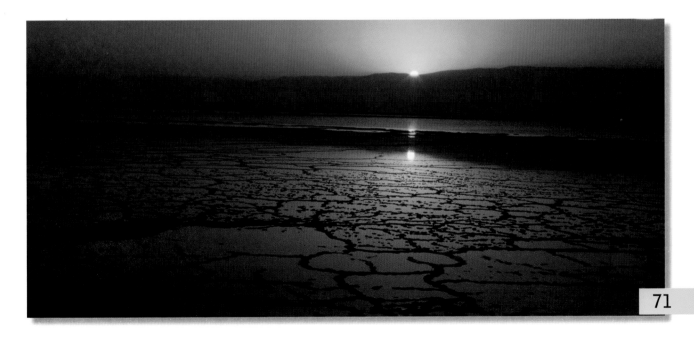

BEERSHEBA

Beersheba, the "well of the oath", was named by the Patriarch Abraham who came here seeking water and made a pact with Abimelech. Today, it is a fast-developing, vibrant city and capital of the Negev. Modern architecture can be seen in the well-planned Ben Gurion University of the Negev, the hospital, shopping complexes, municipal buildings and new neighbourhoods. Houses and schools are designed to withstand the heat and dryness of the desert days, and the drop in temperature at night.

The market held here every Thursday morning is a meeting place for the Bedouin of the Negev who come to trade their livestock and produce. Most of Israel's Bedouin have abandoned their goat-hair tents, flocks of sheep and goats and migratory life-style and live in permanent buildings, working for a daily wage. However, family, tribe and clan are still their most important values and they are renowned for their hospitality, as demonstrated in the Bible by Abraham.

below: Partial aerial view of Beersheba

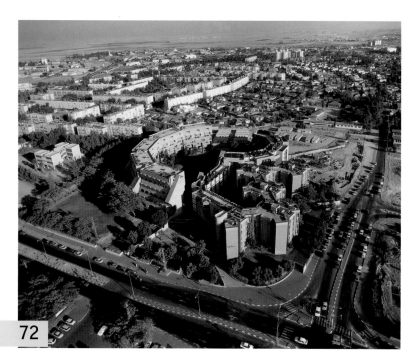

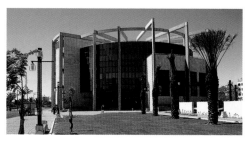

Modern buildings in downtown Beersheba.
opposite: The Bedouin market
opposite below: A camel tour in the Negev.

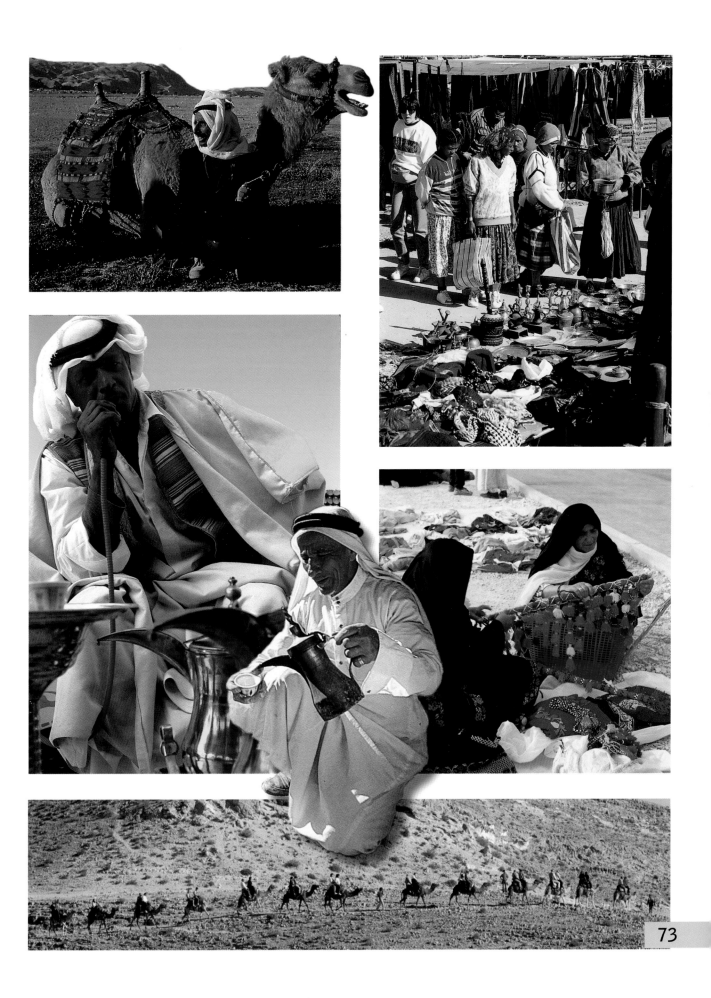

The main street of Ashdod.

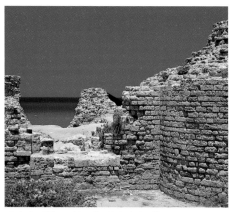
Ashdod Yam (Ancient Ashdod)

ASHDOD

Situated on the Mediterranean coast, Ashdod was built in 1957. It is centred on Israel's largest and newest port which was originally planned chiefly for the export of citrus fruit. Today it is a busy, thriving industrial city with a vibrant cultural life.

Ancient Ashdod was a major Canaanite town set along the Via Maris. Later it became one of the five Philistine cities along with Ashkelon, Gaza, Gat and Ekron which were constantly warring with the Israelites and kingdom of Judah.

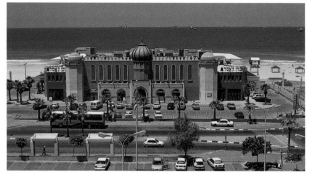
Ashdod

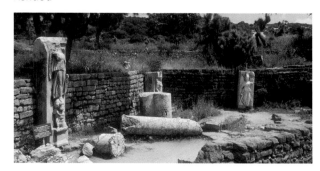
Archeological remains in the National Park of Ashkelon.

ASHKELON

Ashkelon is thought to have been the birthplace of Herod the Great and is mentioned several times in the Bible, connected to the stories about Goliath and Samson. During the ages it was often an important port city and briefly served as a place of refuge for Cleopatra. The beautiful National Park includes the ancient Tel which has buildings, columns, capitals and statues from the Canaanite, Roman and Crusader periods.

Today it is a modern holiday resort with a large Marina.

Ashkelon's Marina

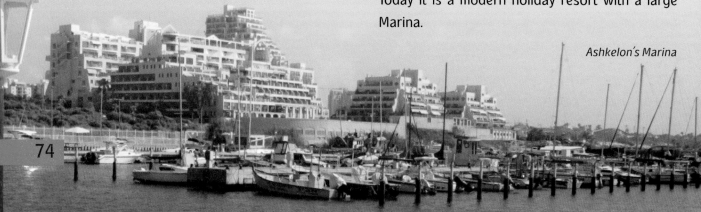

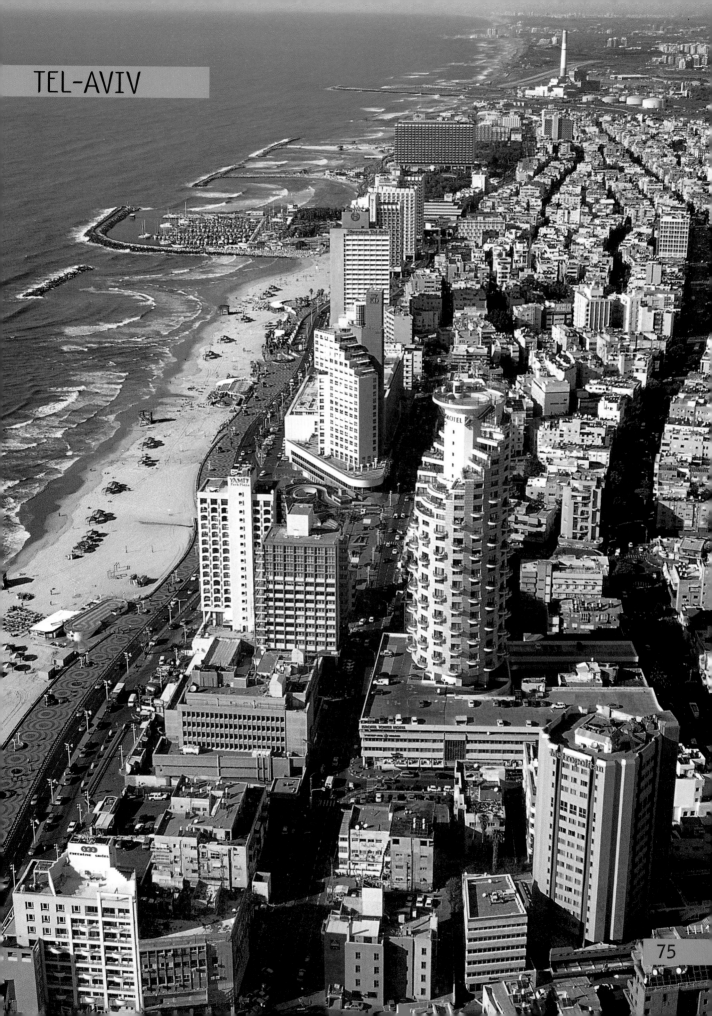

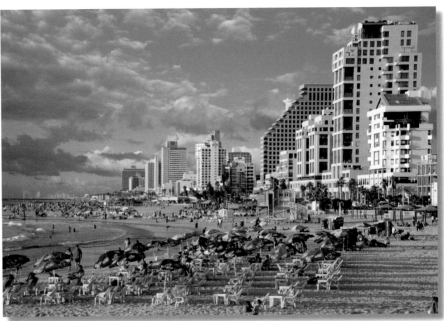

Tel-Aviv was the first Jewish town to be established in Israel in modern times. In 1909, sixty-six Jewish families from Jaffa built the first Jewish neighborhood called "Ahuzat Bayit" and gradually others were added until it became the center of Jewish settlement in Palestine. Seeking to transplant the latest European ideas of urban development to the shores of the Mediterranean, it was built with wide boulevards and many buildings in the Bauhaus style. In 1948 it was here that David Ben-Gurion declared the independence of the State of Israel.

Today Tel-Aviv is Israel's second largest city after Jerusalem, a fascinating combination of the old and the new. It is the commercial capital of Israel and a busy metropolis. Major industrial, commercial and financial concerns have their headquarters here and it is also popular with tourists for its beautiful beaches, markets and non-stop nightlife. It is home to the world-renowned Israel Philharmonic Orchestra, theatre companies, opera and museums, both art and history of the Jews (the Diaspora Museum) and Israel. In 2003, UNESCO declared "The White City", the central part of Tel Aviv, to be a World Heritage site.

above left: Downtown Tel Aviv
above: The beach
below: Panoramic view of Tel Aviv's skyline.

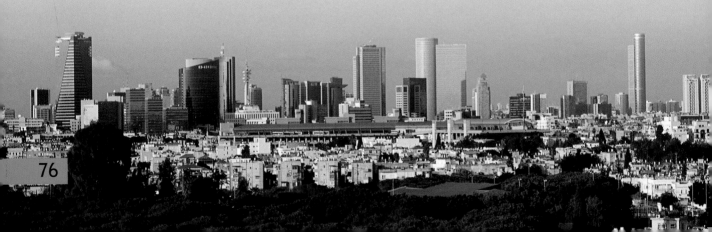

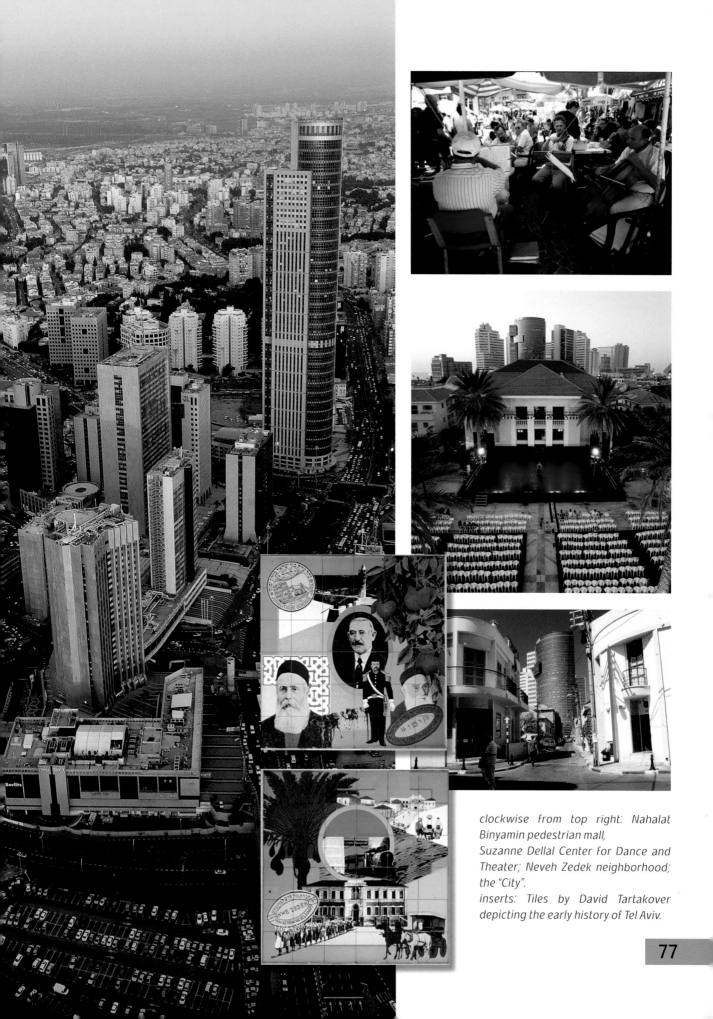

clockwise from top right: Nahalat Binyamin pedestrian mall, Suzanne Dellal Center for Dance and Theater; Neveh Zedek neighborhood; the "City".
inserts: Tiles by David Tartakover depicting the early history of Tel Aviv.

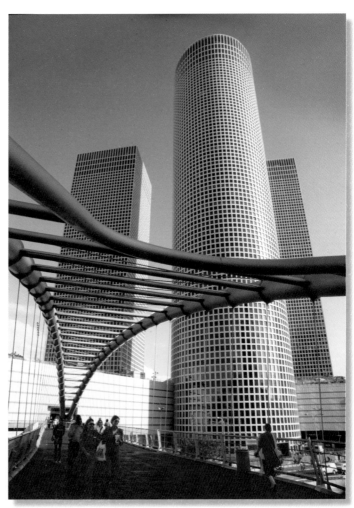

top: The restored Tahana Railway Station complex
above: The Golda Center for the Performing Arts.
right: The Azrieli towers
below: Tel Aviv beach

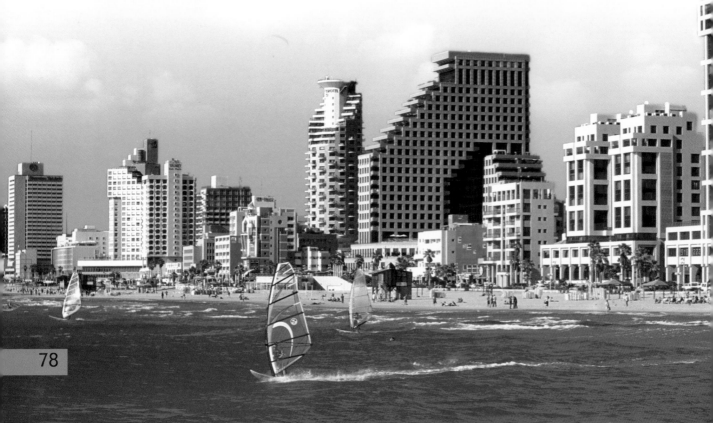

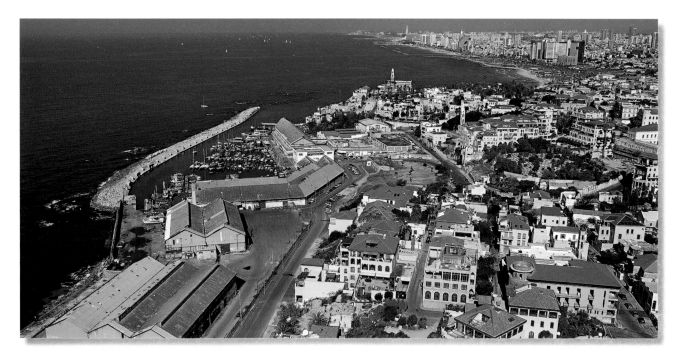

OLD JAFFA

above: Aerial view of Old Jaffa
below: Views of the Artists' Quarter with its narrow, picturesque lanes.

Biblical Joppa was named after Japhet, the son of Noah. An ancient Canaanite city and port, it has many associations with the Bible. Jaffa was part of the allotment of the tribe of Dan and as the only Mediterranean port served all the rulers of the Holy Land. Solomon imported cedars from Lebanon through Jaffa to build the Temple in Jerusalem. From here Jonah set off on his journey to Tarshish and was swallowed by a whale (Jonah 1:17). In Jaffa Peter raised Tabitha from the dead, and it was the home of Simon the Tanner. The port lost its importance for a while when Herod built his harbour at Caesarea but was always used by European visitors and settlers. During the Crusader period it was a center of fighting and Napoleon's troops were quartered here after their retreat from Acre in 1799.

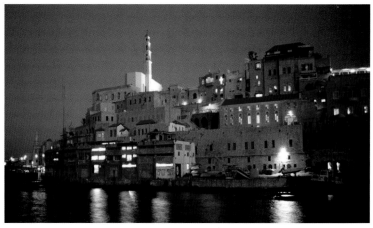

left: Jaffa's famous clock tower, built in 1906 in honor of Turkish sultan Abdul Hamid II.
above: Old Jaffa at night.
below: The old port of Jaffa with the lighthouse.

After Tel Aviv was founded, most of the Jews moved away but the two cities were united into a single municipality in 1950. Today, the beautifully restored Old Jaffa offers all the modern tourist facilities together with the quaint charm of the artists' quarter, where one can browse amongst works of art of all kinds and at all prices and enjoy its spectacular views and many fish restaurants. St. Peter's Church, founded in 1854 by the Franciscans, is visible miles out to sea.

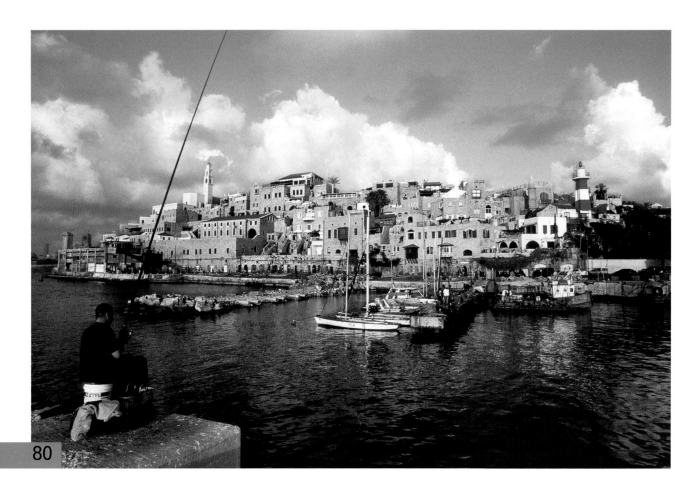

NETANYA

On the shores of the Mediterranean Sea, Netanya has developed into one of Israel's foremost resort towns. Hotels, pensions and private homes offer all types of accommodation to the holidaymaker.

Views of Netanya, Israel's popular resort town.

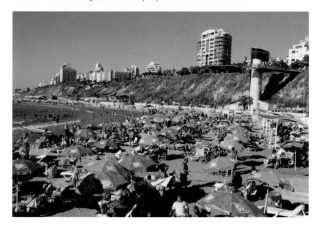

Beautiful stretches of golden sand make this the ideal venue for family holidays.

Below: The Victory Monument dedicated to the Red Army for their part in World War II

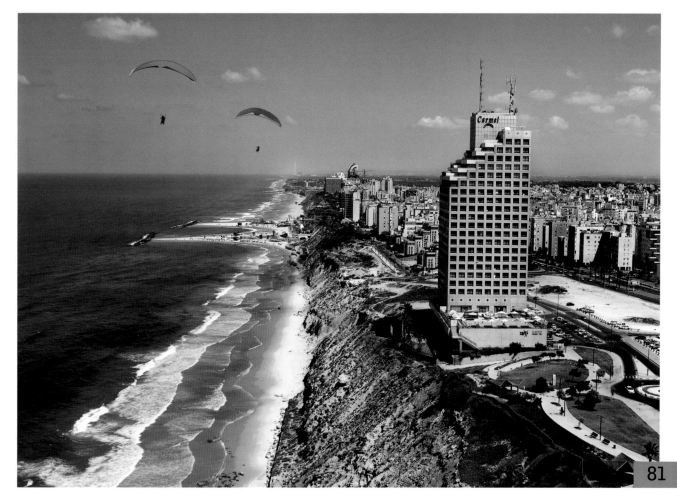

CAESAREA

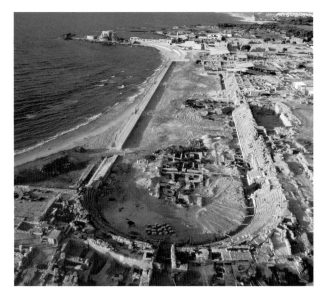

Built by Herod the Great on 20 BCE on the shores of the Mediterranean and named for Caesar Augustus, Caesarea was one of the most splendid cities of the ancient world, filled with all the luxuries that constituted Greco-Roman culture. Its population could enjoy chariot races at the massive hippodrome and performances at the 5000-seat theatre and pray in the temple. Beautiful gardens and courtyards were watered by Roman aqueducts and buildings and baths were decorated with the finest mosaics. Its busy harbor was silt-free with artificial breakwaters and illuminated by a lighthouse. The heyday of Caesarea was in Byzantine times, when Christianity took over the Roman Empire and the city attracted scholars from far and wide. At the beginning of the 12th century, the Crusaders discovered the Holy Grail here and rebuilt and fortified the city, building a moat, but it was finally lost to the Mameluks in 1265. Thereafter it became a backwater until excavated in the 1950's and 60's.

Today it is an important tourist destination with restaurants and artworks displayed in the artists' yard. Caesarea houses Israel's main golf course and many luxurious villas.

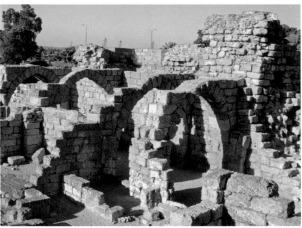

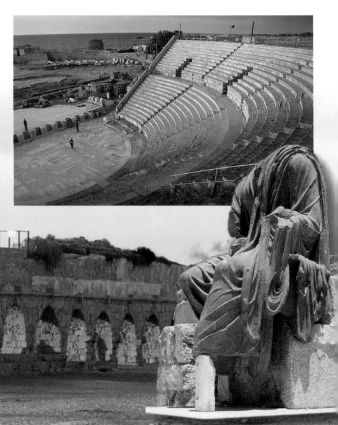

from top: The Roman Hippodrome
Excavated ruins of the Crusader city.
The Roman theater, today a popular venue for summer performances.
The ancient aqueduct, spanning a popular beach.
right: Remains of a Roman statue.

HAIFA

The city of Haifa is built above the harbor on the slopes of Mount Carmel. It is dominated by the gold-plated dome of the Baha'i Shrine set in magnificent Persian hanging gardens. This is the center of the Baha'i faith which stresses the unity of God and the brotherhood of mankind.

One of the few cities not mentioned in the Bible, Haifa developed in importance when Acre's port became too small to support modern shipping. The arrival of a group of Christian German Templers in the late 19th century was a turning point. They opened factories and developed communications with other towns, thereby modernizing the city. The Hejaz railway line built by the Turks in 1905, the construction of the harbour by the British in 1933 and the refineries in 1934 all resulted in its rapid development.

Today Haifa is Israel's third largest city after Tel-Aviv and Jerusalem with several hi-tech parks, important academic institutions including the world-famous Technion, an industrial port, grain silos, and petrol refinery. It is also home to several

Partial view of Haifa with the Baha'i Center, the port and silo.

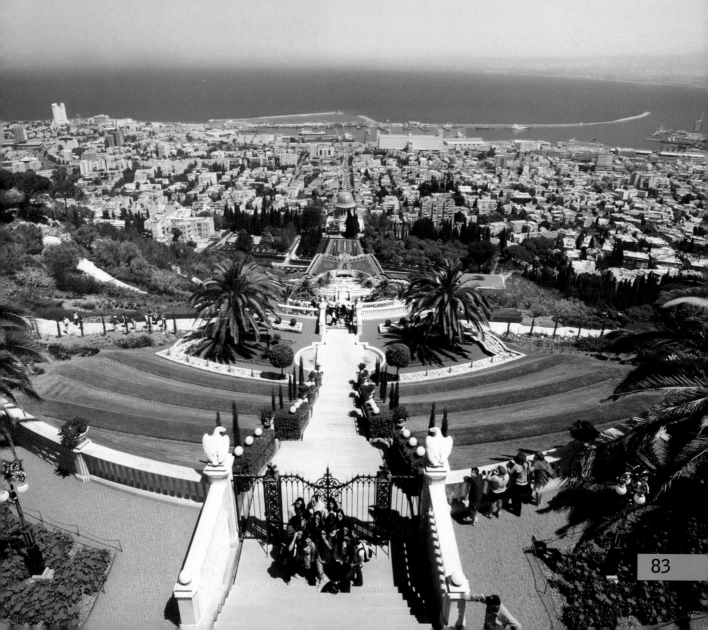

museums - the Maritime Museum, Naval and Illegal Immigration Museum, Museum of Antiquities, Museum of Modern Art, the Municipal Museum and the Museum of Japanese Art.

Pre-historic man once lived in the caves of the Carmel and the range is mentioned in the Bible as a place of beauty, worship and retreat. This is indeed true of the Carmelite Monasteries where tranquillity reigns supreme. Stella Maris Monastery in Haifa can be reached by road or cable car. A cave beneath the monastery is believed to have been the refuge of Elijah when he hid from Ahab though according to Jewish tradition, this cave is further

clockwise from top: The Baha'i hanging gardens.
The cable car to Stella Maris monastery.
Haifa District Government Center in "Sail" Tower.
Partial view of Haifa.
The old Technion, today the Science Museum.
The Baha'i Shrine with its magnificent terraces at night.

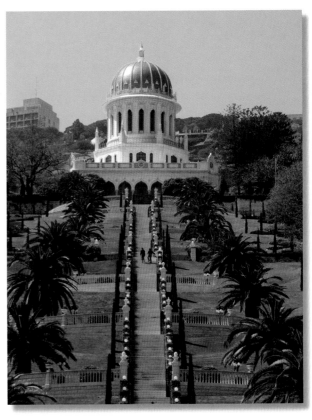

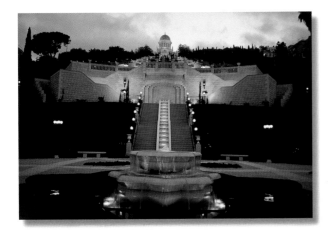

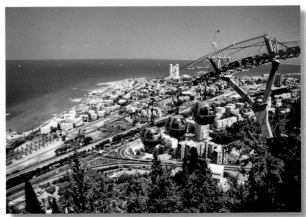

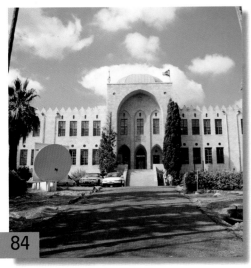

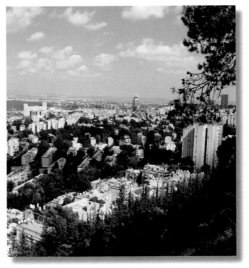

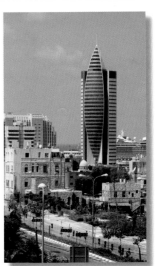

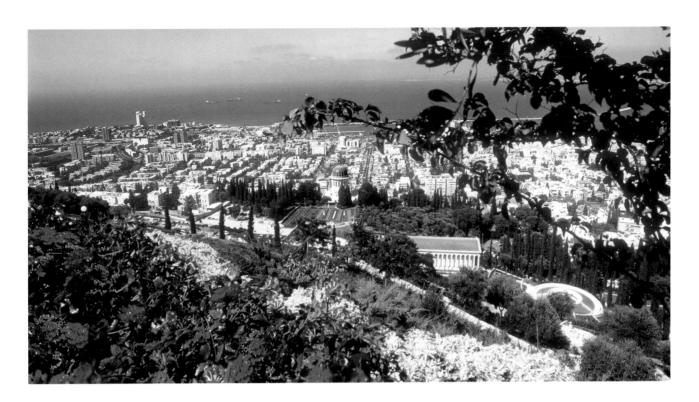

down the mountain. Another Carmelite monastery at Mukhraka marks the traditional site of Elijah's contest with the prophets of Baal (1 Kings 18). Near Haifa, on the heights of Mt. Carmel, are the

picturesque Druze villages of Daliat el-Carmel and Isfiya with their large range of Druze arts and crafts in the main streets.

above: General view of Haifa.
right: Stella Maris Carmelite monastery.
below: Elijah's cave.
Statue of Elijah from the Mukhraka Carmelite monastery.

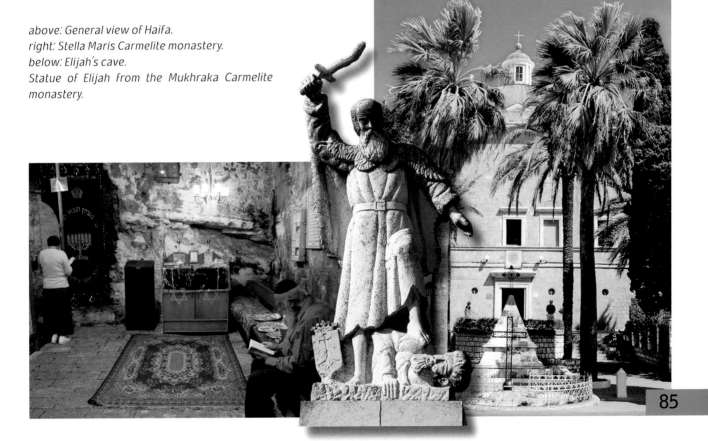

THE JEZREEL VALLEY

The Valley of Jezreel is the largest valley in Israel, cutting the country in two between Galilee and Samaria. It was part of the Via Maris, the main route for the passage of armies and caravans from the coastal plain to the Jordan Valley. The entire area was a malarial swamp until the land was reclaimed by Jewish settlers. Malaria was slowly eradicated, and the valley became green and fertile. Today it is populated by kibbutzim and guest houses, and provides a high percentage of the country's fruits, vegetables and farm produce.

below: View of the Jezreel Valley
insert: Lion seal discovered at Megiddo, bearing the name of Jeroboam King of Israel.
bottom: Aerial view of the archaeological site of Megiddo.

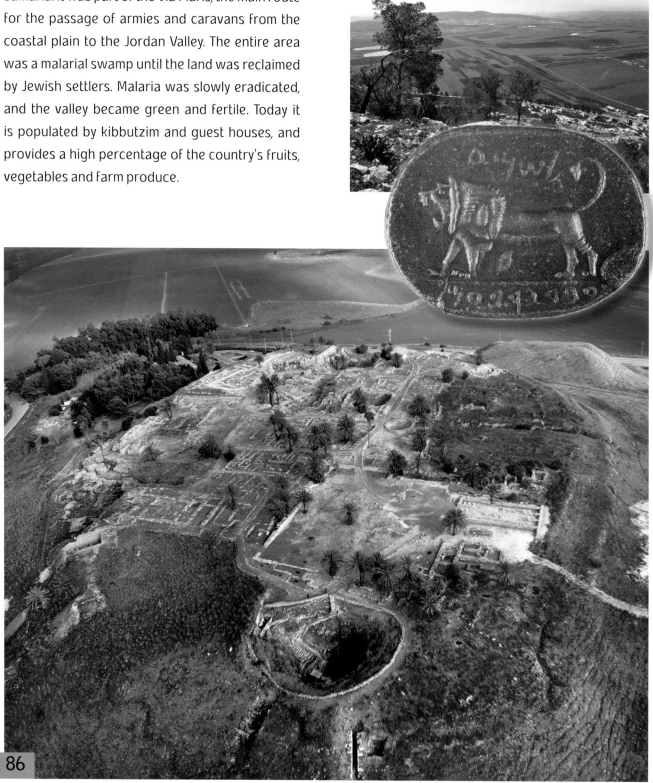

MEGIDDO

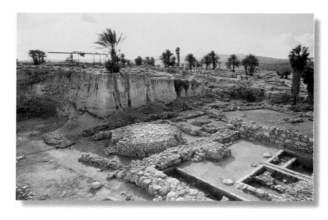

Megiddo is situated on the Via Maris. In the past it was a major battleground due to its strategic location and importance, connecting the towns in the center of the country with the sea. It is the site of history's first recorded battle in 1468 BCE between the Canaanites and Egyptians. The New Testament claims that Armageddon (Megiddo) is where the final battle between the forces of good and evil will take place.

Megiddo was one of the walled city-states taken by Joshua. Excavations carried out at the tel in 1925 revealed twenty five layers of civilization superimposed one over the other; the oldest dates back to 4,000 BCE.

Remains can be seen of a partially restored walled town with superb gates, and models explain the complicated archaeological complex. An underground water tunnel linked the inhabitants to the water source located beyond the walls. A Canaanite temple, palaces, storehouses, sentry towers and soldiers' quarters were all contained within the walls.

from top: The excavations; the water tunnel; mosaic discovered in 2005 in a third century Christian prayer hall at Megiddo (Israel Antiquities Authority); remains of the city gate.

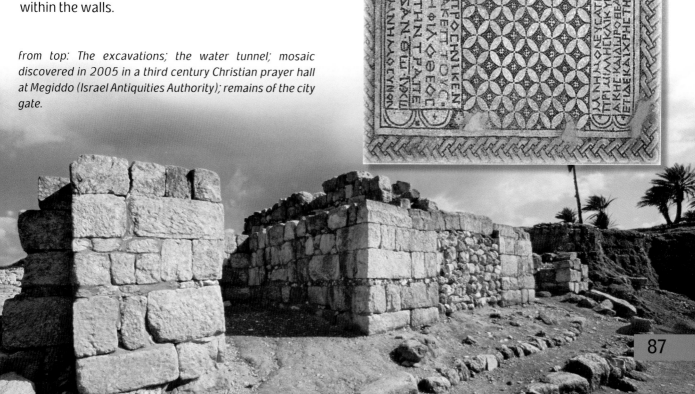

ACRE (AKKO)

In the Bible we learn that Akko and its surroundings fell to the lot of Asher after Joshua overran Canaan and divided it up among the tribes of Israel. The Canaanites and the Asherites lived together in this thriving sea port on the Via Maris which was established some 4,000 years ago. Acre is mentioned in the Amarna letters as a prosperous sea port. It was later conquered by Alexander the Great and granted permission to mint its own coins. Renamed Ptolemais, it continued to thrive. The Romans used it as a headquarters to launch their attacks against the Jewish strongholds in Galilee. In 1187 Acre became the Crusader capital of the Holy Land. The Crusaders built massive underground halls, now beneath the Turkish Citadel, and the Knights' Halls are today the venue for concerts and other performances, a unique underground experience. The Crusaders were ousted by the Mameluks in 1291. Under the Ottomans it became a backwater until the rule of local chieftain, Ahmed el-Jazzar. In 1775 he built the Great Mosque with its marble pillars and elaborate decorations. This distinctive landmark can be seen for miles around. The hot baths, now the Municipal Museum, were also erected by el-Jazzar who in 1799 succeeded in rebuffing Napoleon.

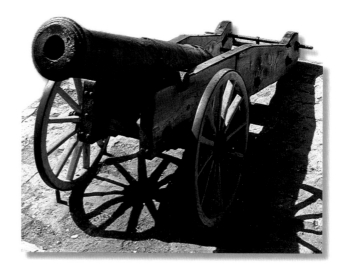

below: One of many Turkish cannons that once guarded Acre's ramparts.
bottom: Aerial view of Acre showing the city walls and the port.

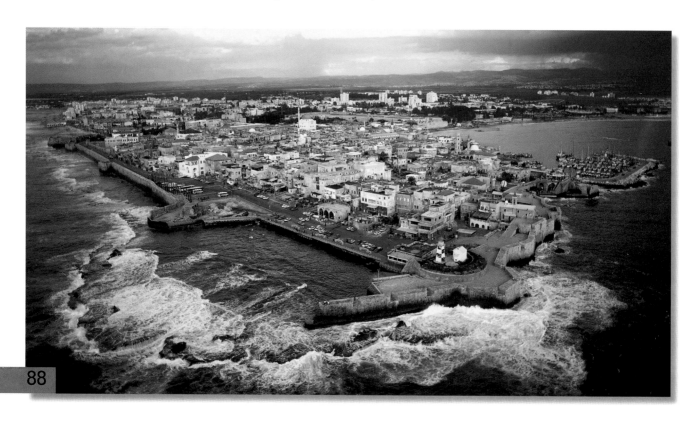

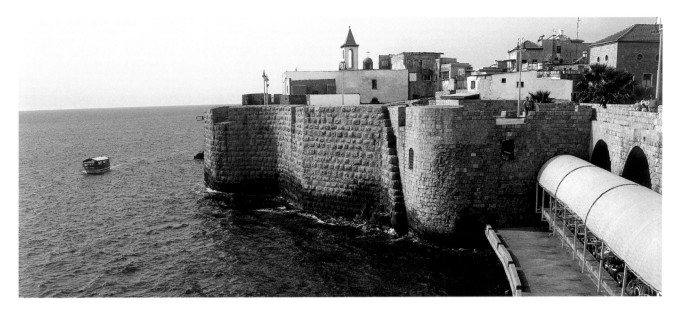

Acre was included in the British Mandate of 1918. With the Declaration of Independence in 1948 it began to develop and expand. In 2001, the walled city was recognized as a World Heritage Site.

The colourful oriental bazaar, the port and the old city walls are all popular with tourists and annual festivals for music, theatre and dance are held here.

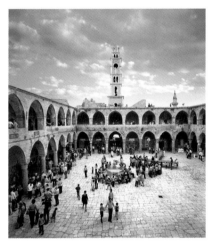

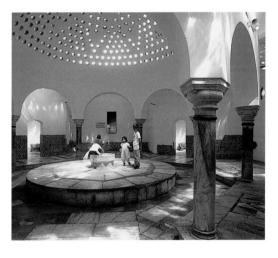

top: Partial view of the sea wall and old city.
center from left to right: 18th century Khan el-Umdan (Inn of the Columns) with its famous clock tower. The khans were used by merchants when Acre was an important commercial center and the only port serving the north.

View of the sea-wall; The Municipal Museum, housed in the Hammam (old Turkish baths).
bottom: The skyline of Acre with the Mosque of El Jazzar and the many minarets.

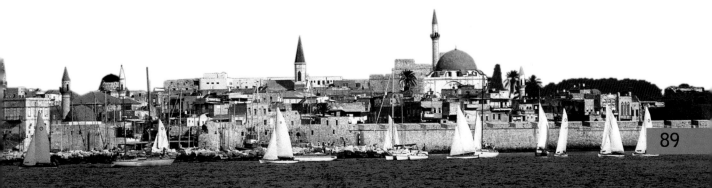

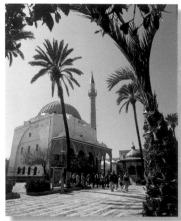
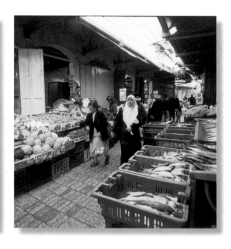

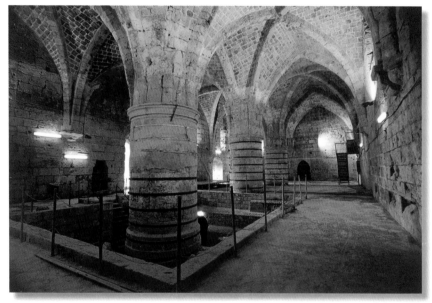

clockwise from top left: Interior of Al Jazzar Mosque; El Jazzar Mosque; the market; Acre's 18th century citadel; the fishermen's port; St. John's Crypt.

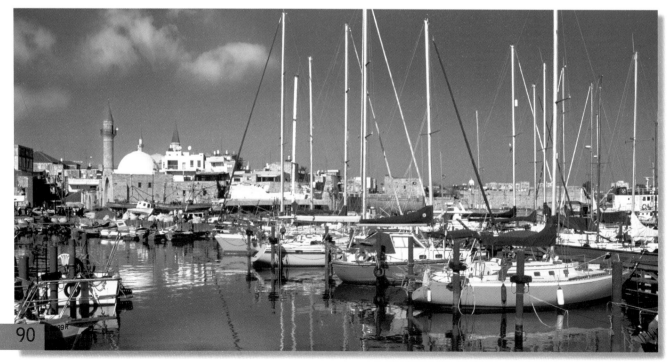

ROSH HANIKRA

Natural grottos at Rosh Hanikra have been formed by the constant action of the sea against the white chalk cliffs and are connected by artificial tunnels. This point on the Israel-Lebanon border has now become a favourite tourist attraction and the caves are accessible by cable-car.

Kibbutz Lohamei Hageta'ot close by adjoins part of the Turkish aqueduct which once carried water from the Spring of Kabri to Acre.

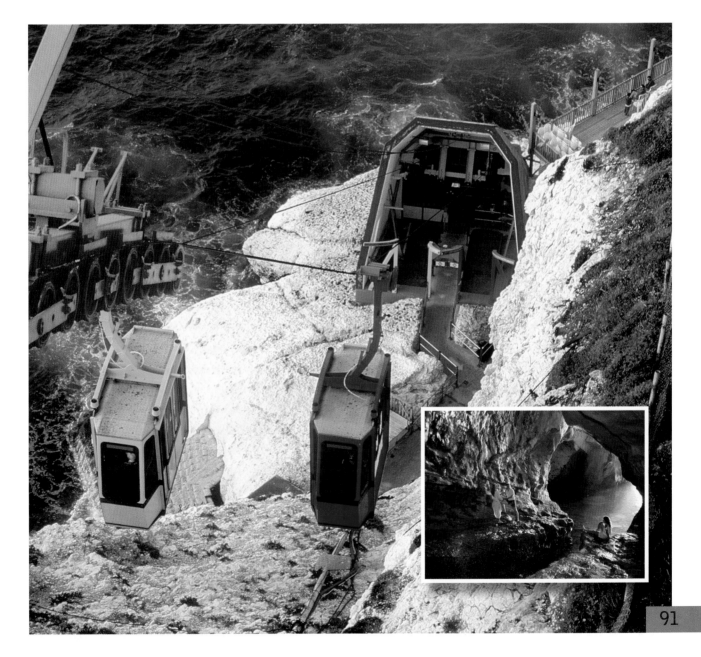

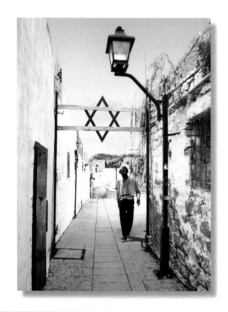

SAFED

Views of the lanes of Safed.
center: Interior of the Ari synagogue.
below: Aerial view of Safed with the Sea of Galilee in the background.

The capital of Upper Galilee, Safed, is perched 3,000 feet above sea level, high up on a mountain top. The wonderful views from every narrow lane and alleyway, the crisp mountain air and the mystical setting all combine to make this a popular holiday venue. Painters, sculptors and craftsmen are drawn to the renovated Artists' Quarter where many have workshops and galleries.

During the War of Independence Safed was the scene of furious battles and miraculously the outnumbered Jewish citizens won. The Davidka - a small gun that makes a lot of noise - still stands in the main street as a memorial to the fallen of the War.

Safed is home to Kabbala, Jewish mysticism. The Zohar, its basic work, was traditionally written in the Second Temple era by Rabbi Shimon Bar-Yohai whose grave is nearby in Meron and Jews expelled from Spain flocked to the area in the 16th century. The first Hebrew printing press in the Middle East was set up here in 1563.

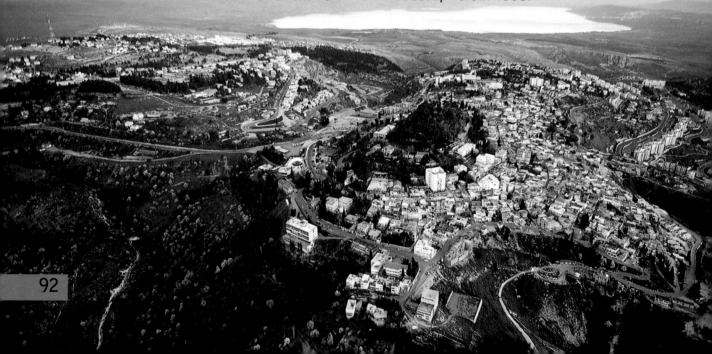

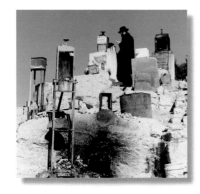
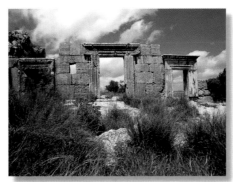

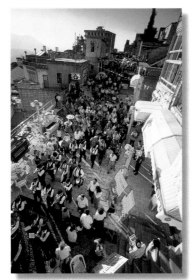
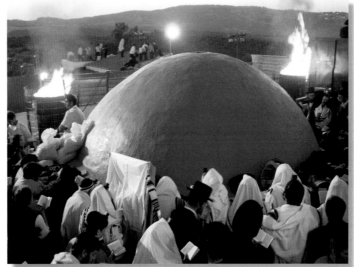

Meron, Safed and Tiberias are home to the graves of many Jewish scholars. clockwise from top left: Praying at the grave of Rabbi Isaac Luria; remains of the 2nd century synagogue at Meron; tomb of Rabbi Jonathon the Shoemaker at Meron; Lag B'Omer bonfires at Meron; burial cave; grave of Rabbi Yonatan Ben Uziel at Amuka - it is believed that singles who visit will marry within a year; the old cemetery of Safed; Klezmer festival in Safed.

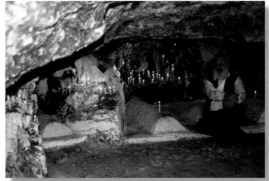

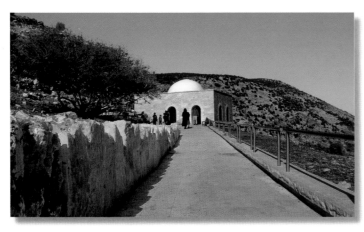

ZIPPORI (SEPPHORIS)

Near Nazareth is the archaeological site of Zippori which Josephus described as "the greatest city in all Galilee". It was built by Antipas, son of Herod, to serve as administrative centre of the region and later gained prominence as the seat of the Sanhedrin, the Jewish Council. It is traditionally the birthplace of Mary, mother of Jesus, and Joseph and Jesus may well have worked here as carpenters. Archaeologists have excavated a 4000-seat Roman theatre, numerous streets laid out in grid formation and an impressive rock-hewn water system. Many magnificent mosaics have been unearthed, and the beautiful third-century CE Dionysian floor in a reconstructed Roman villa has been dubbed the "Mona Lisa of the Galilee". There are also remains of 12th century Crusader fortifications; from here the Crusaders marched to their crushing defeat by Saladdin at the Horns of Hittim in 1187.

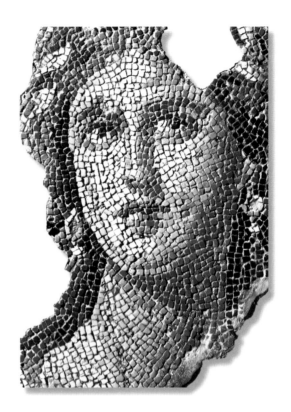

above: "Mona Lisa" of the Galilee, detail of the Dionysiac floor mosaic from a 3rd century home.

right: Archaeological remains of a 5th century street.
below right: Mosaic found in the 5th century synagogue.
below: Reconstruction of life in Talmudic times.

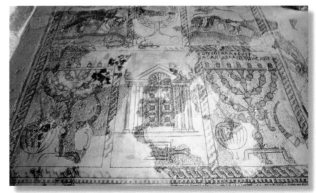

NAZARETH

The city of Nazareth is located in a valley in southern Galilee. It was here that Joseph and his wife, Mary, lived, and Jesus spent his childhood. In the first centuries CE, Nazareth was populated only by Jews, but with the strengthening of the Roman Empire, the number of Christians living there grew. From the fourth century onwards, churches were built on the sites which were connected with Jesus and the Virgin Mary.

Today the population of Nazareth is a mixture of Christians, Moslems and Jews. The Christians belong to various denominations: Orthodox, Roman Catholic, Greek Catholic, Maronite, Anglican, Copt, Armenian, Baptist and other Protestant sects. There are many churches, monasteries, convents, hostels, hospitals and schools maintained by the religious organizations.

right: The Church of the Annunciation.
below: Nazareth as seen by David Roberts in 1839.

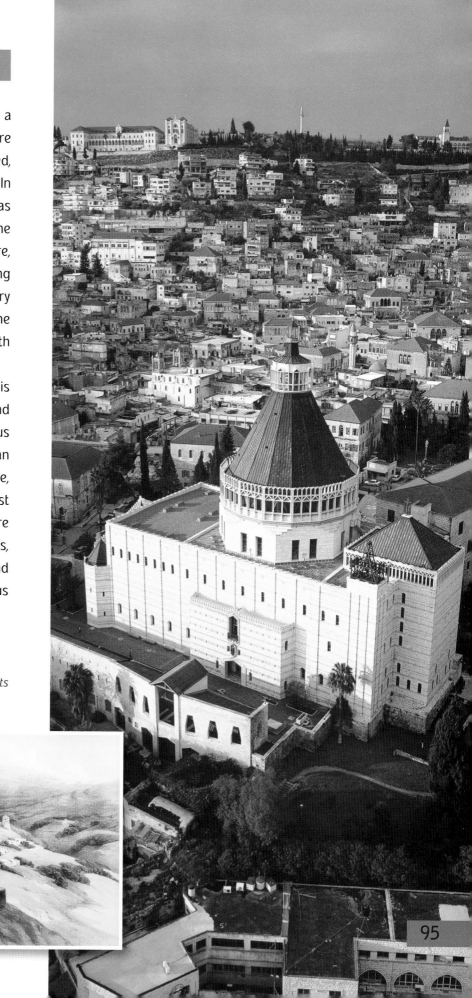

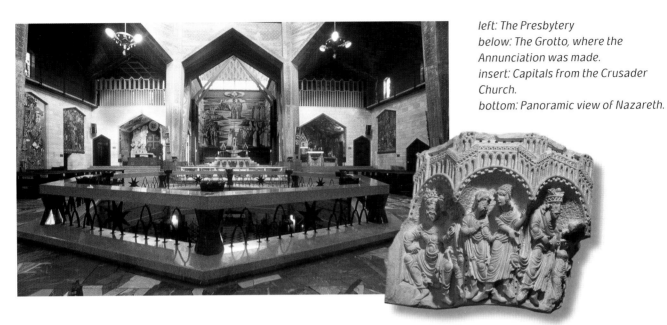

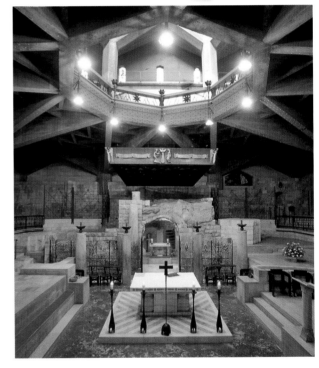

left: The Presbytery
below: The Grotto, where the Annunciation was made.
insert: Capitals from the Crusader Church.
bottom: Panoramic view of Nazareth.

Every view of Nazareth is dominated by the Basilica of the Annunciation. The present Basilica, which was designed by the Italian architect, Prof. Giovanni Muzio, was completed in 1969. It is the fifth church built on the spot where the Angel Gabriel stood when he prophesied to the Virgin Mary that she would conceive a child. Remains of the first church were discovered during excavations which were started on the site in 1955. The second church was built during the Byzantine period; the third at the beginning of the 12th century and the fourth in 1730 and enlarged in 1877. The current Basilica was completed in 1969.

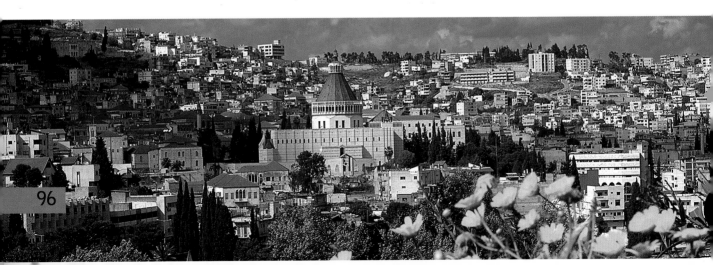

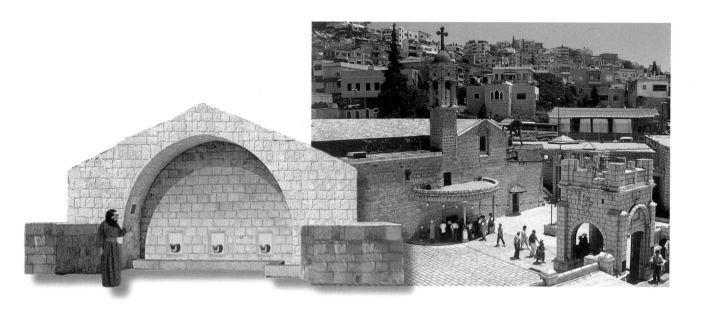

MARY'S WELL

Spring water is carried by an aqueduct to Mary's Well, close to St. Gabriel's Church. Today, as in biblical times, the water is drawn in clay jars from the ornamental fountain, and carried away by donkeys.

above: Mary's Well
below: The Grotto beneath the Church of St. Joseph, with silos.

THE CHURCH OF ST. GABRIEL

Close to Mary's Well is the Church of St. Gabriel. Built by the Crusaders in the 12th century, the original church marked the place where it is traditionally believed that the Angel Gabriel first appeared to Mary. In 1781 the Greek Orthodox community built the present church.

above right: The Greek Orthodox Church of St. Gabriel, where the angel Gabriel first appeared to Mary.
below: Market scene

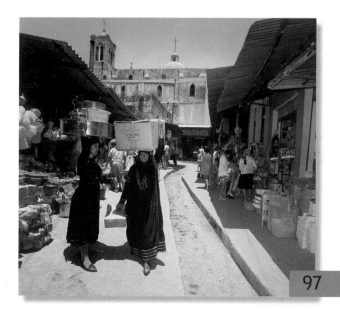

KFAR CANA

The little village of Kfar Cana, close to Nazareth, is identified as the site where Jesus performed his first miracle of converting water into wine at a wedding. His mother and disciples were guests at the feast. A painting hanging above the altar in the small church shows Jesus at the wedding. The present church, known as the Church of the Miracle, is constructed on the ruins of a church built in the sixth century CE. Inside there is a mosaic floor from the fourth century. Many young couples come here to celebrate their weddings. In the crypt of the church a Roman water jug symbolizes the larger ones used to hold water at the time of the first miracle.

right: The Greek Orthodox Church of Cana.
below: The Greek Orthodox and Melchite churches.
insert: Jar representing the miracle.

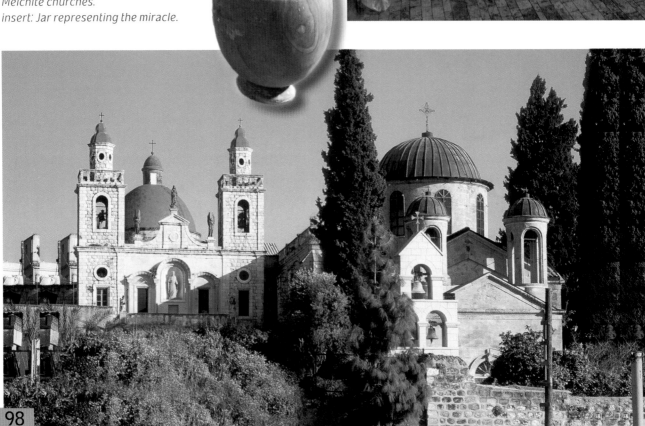

MOUNT TABOR

The rounded mountain in the Jezreel Valley is of great importance to Christians. This is the traditional place of the transfiguration of Jesus. Commemorating this event a modern church was built on the summit in 1924 by the architect Antonio Barluzzi in the Roman-Syrian style of the 4th - 7th centuries. During construction, remains of previous basilicas were discovered. Above the 12th century Crusader altar of the central apse in the Basilica of the Transfiguration is a golden mosaic representing the transfiguration. Jesus is the central figure surrounded by the prophets Moses and Elijah. Depicted below them are Peter, James and John. He was transfigured by them, his face shining like the sun, and his clothing brilliant white. The mountain also figured in the story of Deborah who, together with her general Barak, defeated Sisera (Judges 4).

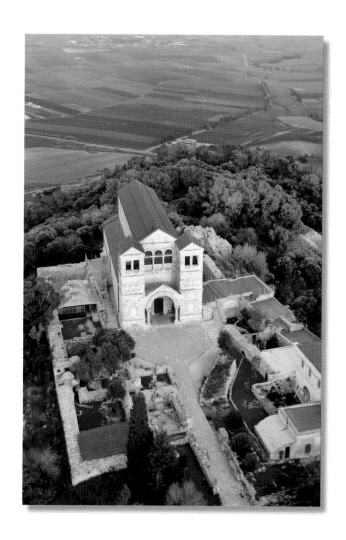

right: Aerial view of the Basilica of the Transfiguration on Mount Tabor.
below: Mount Tabor in the springtime.

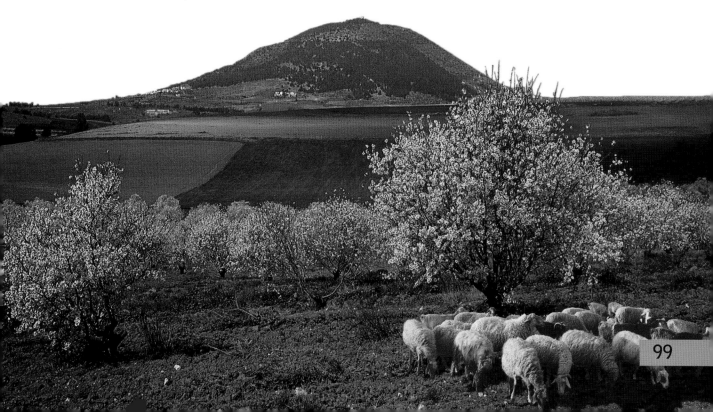

TIBERIAS AND THE SEA OF GALILEE

Capital of the Lower Galilee, Tiberias is situated 209 metres below sea level on the southwest shore of the Sea of Galilee, near the area of Jesus' ministry. Herod Antipas, son of Herod the Great, founded the town around 20 CE and named it for the Roman Emperor Tiberius. It was one of the four holy Jewish cities together with Jerusalem, Hebron and Safed and the Gemara, the second part of the Talmud, was compiled here. It is the burial place of the great Spanish 12th century rabbi Maimonides whose tomb is still visited by pilgrims. Tiberias was conquered by the Arabs in 636 and then by the Crusaders who used it as an administrative center. The black basalt walls are from their times though were restored by the Bedouin chief Daher el-Amar in 1738.

Today Tiberias is a tourist resort and spa, and the nearby hot mineral springs of Hamat Tiberias are as popular now as they were in Roman times.

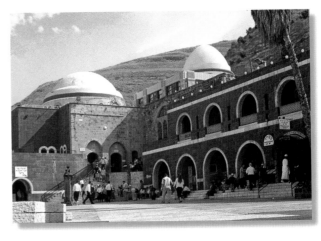

top: The tomb of 2nd century scholar Rabbi Meir Ba'al Haness.
below: One of the many fish restaurants on the promenade.
bottom: Aerial view of hotels, harbor and Sea of Galilee.

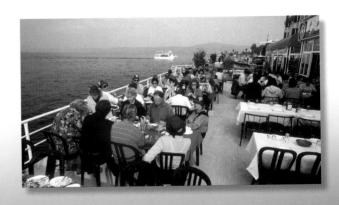

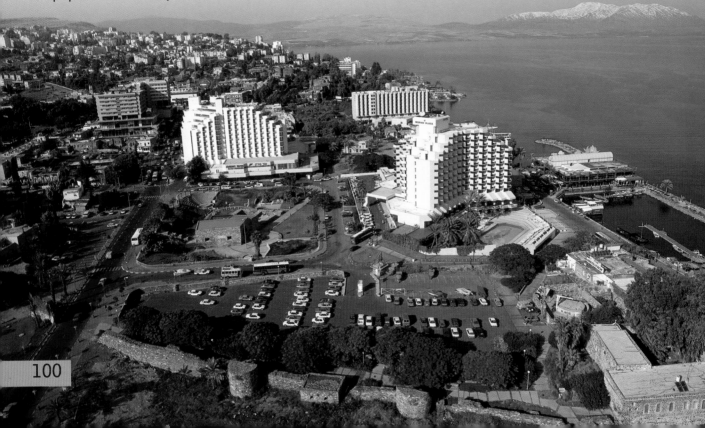

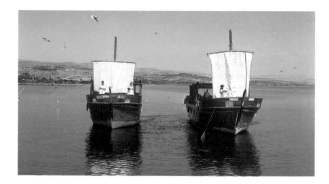

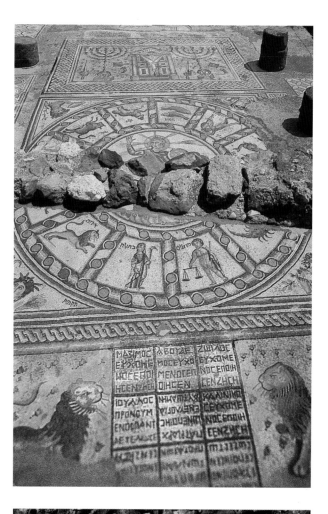

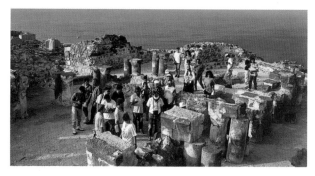

clockwise from top left: Pilgrims' boats on the Sea of Galilee;
Mosaic floor depicting the Zodiac at Hamat synagogue; the
ancient Tiberias hot springs; tomb of Maimonides; General
view of Tiberias; remains of the southern gate of ancient
Tiberias; ruins of the church at Bereniki.

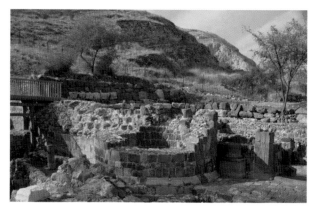

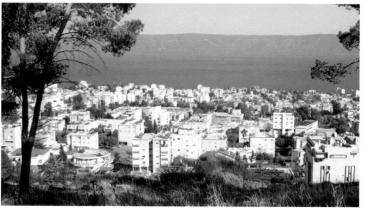

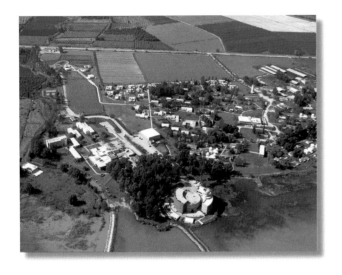

MAGDALA

Home town of Mary Magdalene, Magdala was one of many Jewish fishing villages along the shores of the Sea of Galilee. Its name means "tower", probably referring to a light-house which guided ancient fishermen. Jesus delivered Mary from demons and she was later the first to witness his resurrection. Magdala was excavated in the 1970's when mosaics and a small synagogue were discovered.

MOUNT ARBEL

The high cliffs of Mount Arbel overlook the western shore of the Sea of Galilee. This was the site of a battle in 39 BCE between the zealots living in the caves and Herod's warriors. Josephus tells the story of a father who killed his family and himself rather than be taken captive.

above: Kibbutz Ginossar with the Yigal Allon Museum in the foreground.
View from the cliffs of Mount Arbel to the Plain of Ginossar.

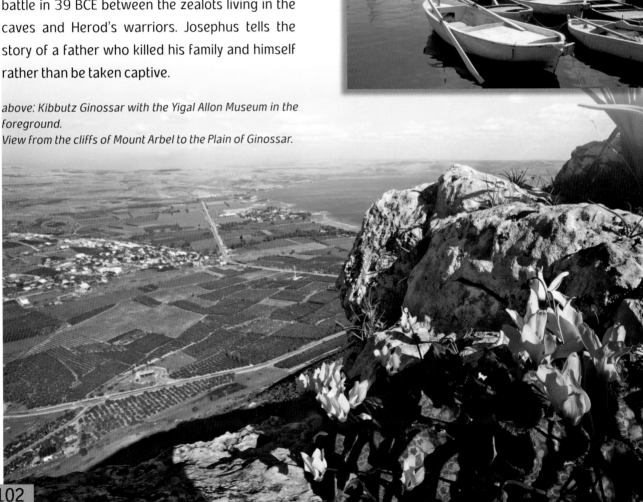

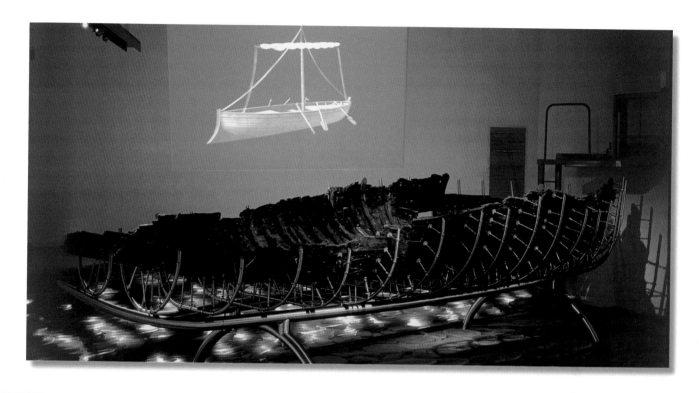

THE ANCIENT GALILEE BOAT

The discovery in 1986 of this ancient vessel, mired in the mud near Magdala on the northwest shore of the Sea of Galilee, caused a stir throughout the world, especially after it was conclusively dated to the fateful first century CE, the time both of Jesus and the Great Revolt of the Jews against the Romans. The boat, made primarily of cedar and oak, is now on exhibit at the Yigal Allon Museum in Kibbutz Ginnosar. It is 9 meters long, 2.5 meters wide and 1.25 meters high. It may have functioned as a ferry boat, but its measurements also suit use by ancient fishermen employing a seine, or dragnet, "cast into the sea" as described in Matt. 13:47-48.

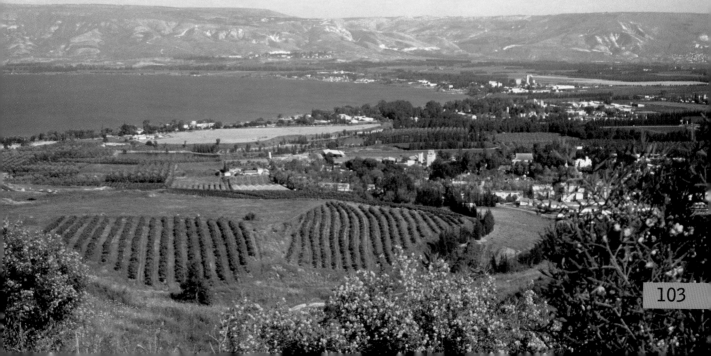

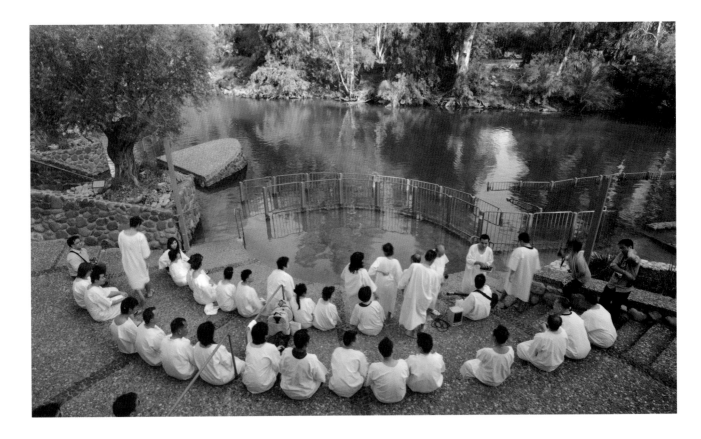

YARDENIT

Near to Kibbutz Degania Aleph, where the River Jordan leaves the Sea of Galilee, is Yardenit, the Place of Baptism. Pilgrims gather here from all over the world and, clad in white robes, they immerse themselves in the holy waters of the River Jordan. Mark (1:9) relates that "Jesus was baptized of John in Jordan" and they are following in the tradition of the scriptures.

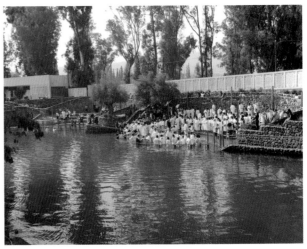

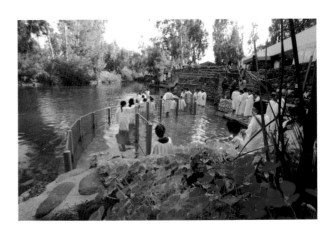

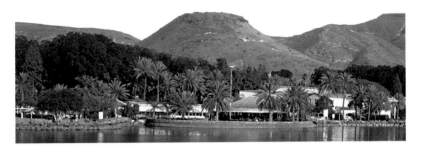
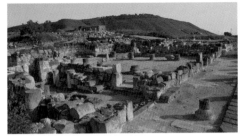

EIN GEV

The kibbutz of Ein Gev on the east bank of the Kinneret was founded in 1939. Once threatened by Syrian forces it is today a flourishing community with a popular fish restaurant and guest house, date and banana plantations. Its concert hall hosts cultural events; most famous is the annual spring music festival. It is also home to a small museum which specializes in fishing techniques as described in the Gospels.

HAMAT GADER

Since the time of the Second Temple, Hamat Gader has been well known for its hot springs. It is situated at the point where Israel, Jordan and Syria meet. Adjacent is a fifth century synagogue floor with Jewish inscriptions. Excavations have uncovered well preserved Roman bath-houses, pottery, coins and glass artefacts. Nearby are modern bathing pools filled with hot spring water and in the pools amongst the trees and tall grasses, where alligators imported from Florida bask lazily in the sun.

SUSSITA (HIPPOS)

On a plateau overlooking the Sea of Galilee, near the eastern shores, lie the ruins of the ancient walled city of Hippos. Its name is derived from the Greek word Hippos meaning horse (as does the Hebrew name Sussita) because of the shape of the rock which resembles a horse's back. During the Hellenistic and Roman-Byzantine periods, from 3rd century BCE to around 700 CE, it was the central city of the Golan. Recent excavations have revealed the impressive plan and structures of the city, including eight churches from the Byzantine period. In 749, the city was devastated by a massive earthquake and it has since remained in ruins.

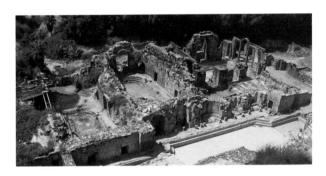

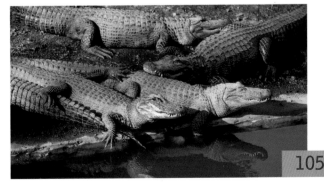

above right: Ruins of the Roman baths at Hammat Gader, the second largest complex in the Roman Empire.
right: The crocodile farm where crocodiles and alligators from Africa and South America live in almost natural surroundings.

TABGHA

The name Tabgha is a distortion of the Greek word Heptapegon meaning "Seven Springs", after seven water sources that flow into the Sea of Galilee at this point. This is the traditional site of the Miracle of the Loaves and Fishes where Jesus fed over 5000 people. The new Church at Tabgha was built over the remains of a fourth century church which itself was built over an earlier church with a beautiful mosaic floor. The mosaic commemorates – the "feeding of the multitude" with five loaves and two fishes. Water birds, local flora and other motifs are also depicted in the mosaics. Like the original building, the church is a large basilica with three naves. The table rock where this miracle took place has been the altar of successive churches.

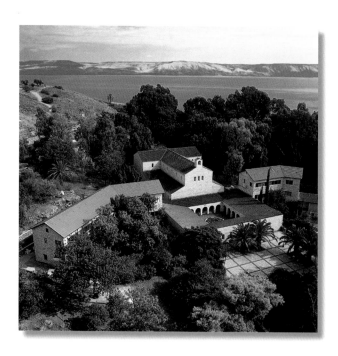

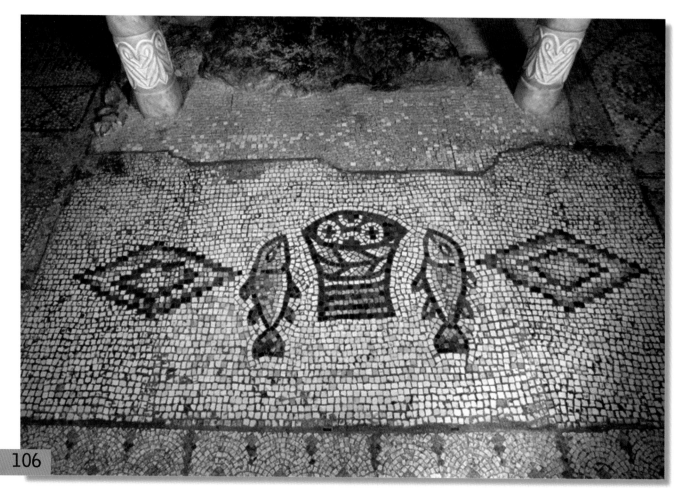

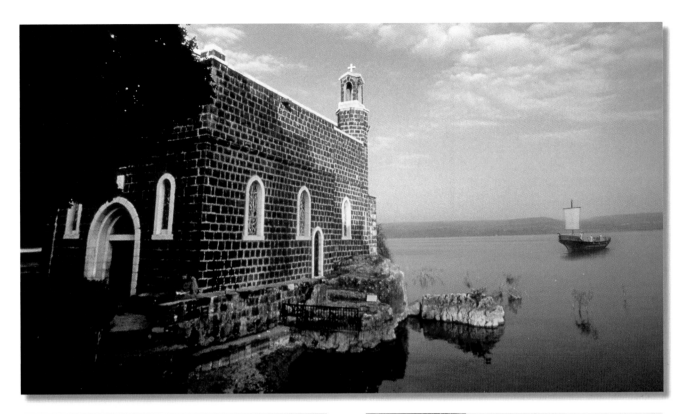

CHURCH OF ST. PETER'S PRIMACY

The simple chapel of the Church of St. Peter's Primacy or Mensa Christi lies nearby on the shore and marks the spot where Jesus came after his resurrection and appointed Simon Peter to the Primacy. The church was built next to ancient steps leading down to the waterline.

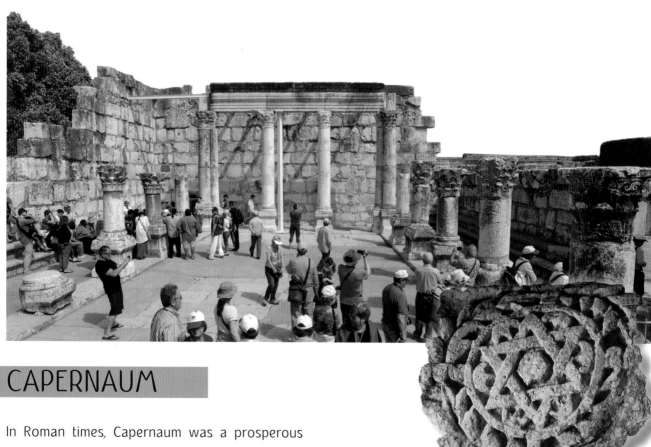

CAPERNAUM

In Roman times, Capernaum was a prosperous Jewish town situated on a major highway. The area has been extensively excavated by the Franciscans who discovered remains of a fifth century synagogue on the site of the original synagogue where Jesus preached, healed the sick, and performed many miracles during his ministry in Galilee. The synagogue had two rows of stone benches and a women's gallery. The beautifully carved white limestone decorations with many Jewish symbols, including a shofar, menorah, star of David and Ark of the Covenant, are in sharp contrast to the simple black basalt homes nearby. An octagonal church from the fifth century was found over what is believed to have been the house of Peter. A circular church has been erected over this traditional site and the remains of the Byzantine church. Millstones and an olive press lie abandoned close to the family living quarters and the new church.

top: Remains of the 5th century synagogue of Capernaum.
above: Relief of a star of David, one of many Jewish symbols that decorated the synagogue.
below: A relief from the synagogue depicting the carriage for carrying the Holy Ark of the Covenant as resembling a Hellenistic temple on wheels.

THE MOUNT OF BEATITUDES

Situated atop the Mount of Beatitudes overlooking the Sea of Galilee, the octagonal-shaped chapel of the Church of the Beatitudes marks the spot where Jesus delivered the Sermon of the Mount (Matthew 5:3-10). Antonio Barluzzi built the octagonal church in 1937 of local basalt. On the walls of the octagon are inscribed part of the text of the eight Beatitudes, as spoken by Jesus (Matthew 5:3-10), with the ninth inside the dome. Colonnaded cloisters surround the entire structure offering a beautiful panoramic view of the Sea of Galilee.

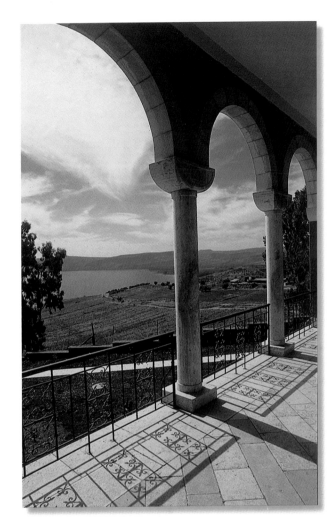

right: Portico of the Church of the Beatitudes looking west.
below: The Church of the Beatitudes with its magnificent view of the Sea of Galilee.

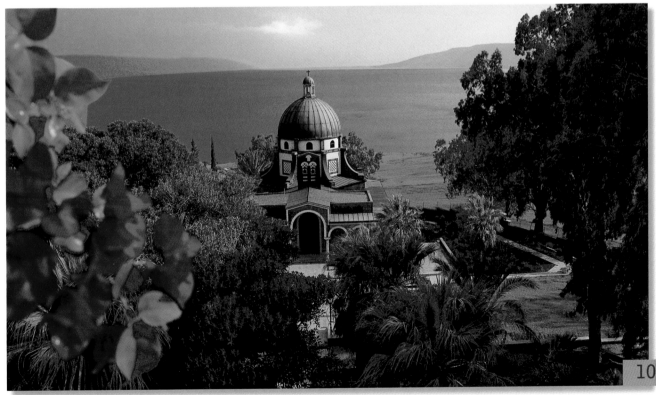

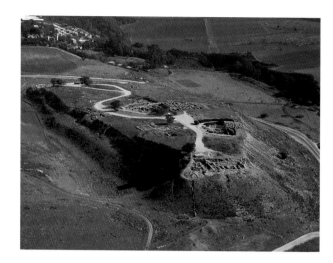

TEL HAI

HAZOR

The statue of a roaring lion was built over the grave of Joseph Trumpeldor who died in battle together with seven other farmer-soldiers defending the nearby settlement of Tel Hai in 1920. Kiryat Shemona "town of the eight" was later named for them. The fort of Tel Hai is today a museum with multimedia exhibits describing the dramatic events.

Hazor was the largest of the Canaanite city-states and strongly resisted the incursions of the Children of Israel (Joshua 11). Archaeological excavations have uncovered 21 layers of civilization. The tel is composed of two sections – the higher, more strongly defended acropolis, and a lower city fortified by a compressed earthen rampart. Solomon's city was razed by the Assyrians in 732 BCE.

above left: Lion orthostat from Hazor, 14th–13th century BCE, Israel Museum.
above right: Bird's eye view of Tel Hazor..

below: The Museum at Tel Hai.
insert: Statue of the roaring lion.

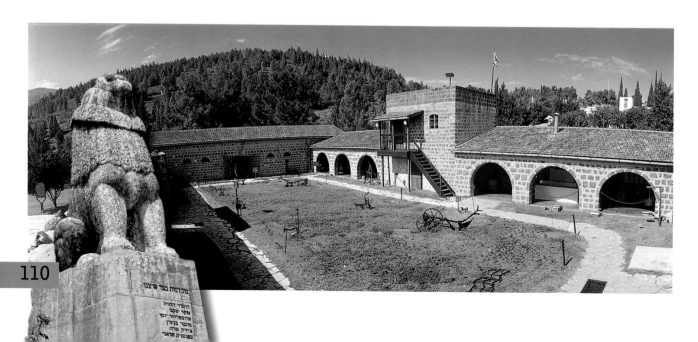

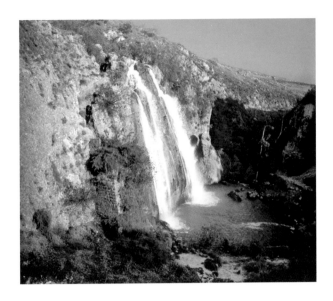

METULLA

On the Lebanese border, the small agricultural town of Metulla with its excellent mountain air has become a popular tourist summer resort. The once sleepy settlement, founded in 1896, now boasts a thriving sports center sponsored by the people of Canada where international competitions and exhibitions take place.

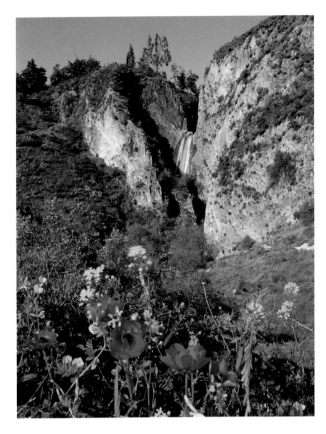

above left: The "Tachana" waterfall.
above: The "Tanur" waterfall.
below left: Manara Cliff cable car above Kiryat Shemona.
below: Rafting on the River Jordan.

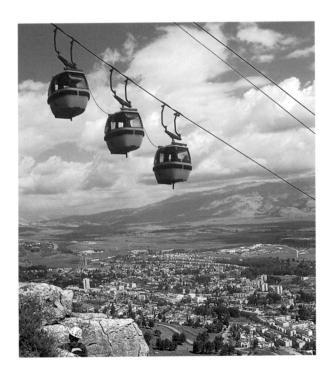

BANIAS (CAESAREA PHILIPI)

below left: *The Banias waterfall on the Golan Heights.*
below: *Remains of the Shrine of Pan at Banias.*
bottom: *Ruins of Nimrod Fortress on the Golan Heights.*

The spring of Banias is one of the three sources of the River Jordan. A Hellenistic town was once built here for the Greek god Pan. The votary niches in the temple to the god overlook lush greenery and bubbling rivulets. The Banias waterfall nearby adds to the beauty of this peaceful setting.

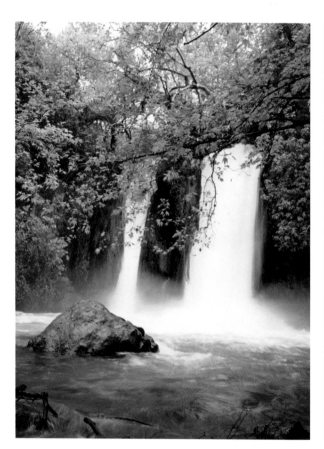

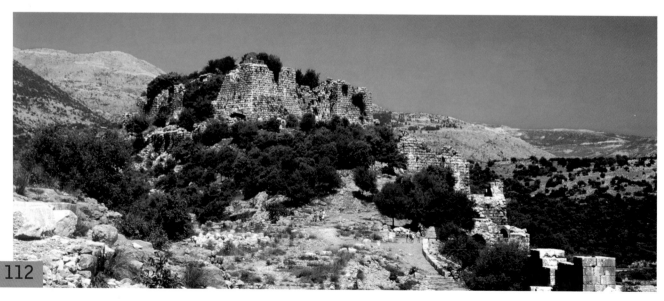

THE HULA NATURE RESERVE

The Hula Nature Reserve is the last remnant of the Hula swamps, once teeming with water buffalo and wild boar, turtles and other water creatures, rare fish and wading birds living a primeval existence among the aquatic plants and creepers.

In 1883, Jewish settlers began draining the swamps by planting eucalyptus trees, which use large amounts of water. This freed vast tracts of land for cultivation and helped to eradicate malaria from the region. However, since 1994, waters of the Jordan have been diverted to enlarge the Hula Lake in order to conserve wild life, and part of the area has been set aside as a nature reserve.

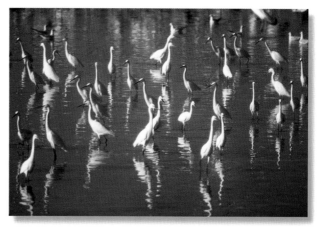

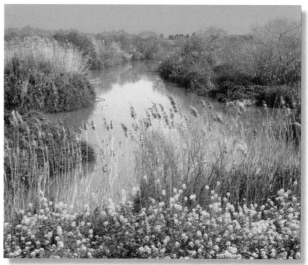

Views in the Hula Nature Reserve.
above: Cranes
below: Storks

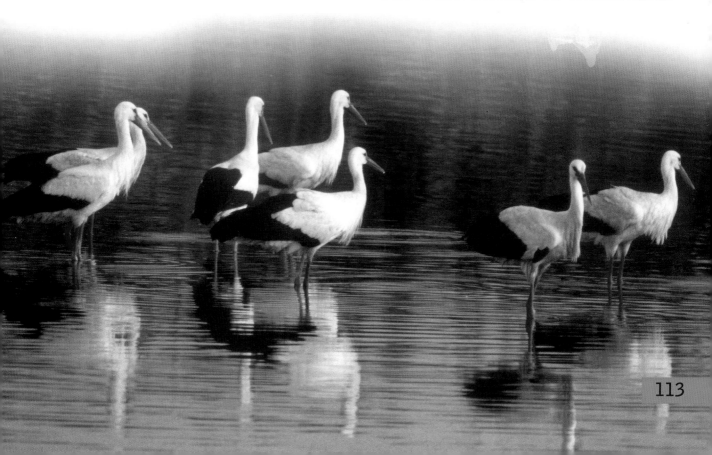

THE GOLAN HEIGHTS

The Golan Heights rise above the fertile Hulah Valley and the Sea of Galilee. Between 1948 and 1967, the kibbutzim in the valley were constantly threatened by fire from the Syrian army which was installed on the mountains. The Six Day War finally ended this threat but remains of the Syrian bunkers and fortifications can still be seen. On the Golan Heights, settlements have sprung up, many agricultural, which are thriving on the fertile soil of the volcanic Heights. Numerous ancient sites have been unearthed in the area, including synagogues and other remains left by the Jewish community that flourished in the area from the second to seventh centuries.

above: Eagles nest at Nachal Saar.
below: Mount Hermon ski resort.

MOUNT HERMON

Snow-capped Mt. Hermon is the highest spot in the country, lying partly also in Lebanon and Syria. The principal peak, resembling an immense truncated cone, is divided into three summits, and the rain and snow it receives affect the water supply of the whole region. At the time of Joshua's conquest, it constituted the northern limit of Israel (Joshua 11:3). It is praised in the Psalms for its abundant water (88, 133). The Hermon is a nature reserve with beautiful flora and many fauna and on its slopes is Israel's only ski site with a chairlift and other facilities. Nearby are several Druze villages. At the juncture of the Hermon and the Golan Heights is a deep, almost perfectly round pool of very blue water. Called Birkat Ram, this strange phenomenon, with no visible inlet or outlet for the mass of water, is the subject of many imaginative stories and legends.

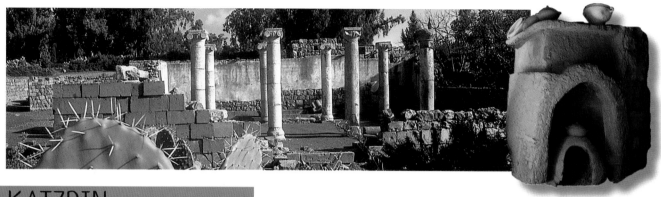

KATZRIN

There was a Jewish settlement at Katzrin at the time of the Mishna almost 2,000 years ago. This is proved by the remains of an ornately decorated synagogue found in the area. Today Katzrin is a thriving town, capital of the Golan with apartment buildings, libraries, community centres and a modern shopping center catering to the needs of the fast growing community. The ancient village has been partially restored, including the synagogue. There is a Museum and a winery where grapes from the area are made into the gourmet Gamla and Golan wines.

GAMLA

The story of Gamla is similar to that of Masada – in fact Gamla is sometimes called the Masada of the North. In 68 CE, at the end of an 8-month siege, many hundreds of the residents of this thriving town leapt to their death from the top of the town which overlooked an abyss, rather than be captured by the approaching Romans. The remains of a first century CE synagogue have been uncovered here.

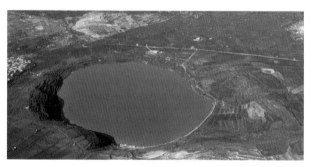

top: The ancient Synagogue at Katzrin.
Inset: Reconstructed ancient ovens in Katzrin Museum
above: Gamla, named for the ridge shaped like a camel's back.
inset: Storks nesting.
above left: The climate and soil of the Golan Heights is ideal for growing grapes.
left: Birkat Ram, a large natural reservoir located in the crater of an extinct volcano. It is fed only by rainwater and an underground spring.

BEIT SHEAN

Beit Shean was an important city in antiquity. Eighteen layers of occupation have been excavated and finds include Egyptian temples and stele. The Bible tells of Saul's death in battle with the Philistines who "fastened his body to the walls of Beit Shean" (1 Sam 31). In the Roman period, it became one of the largest towns in Palestine and expanded further after Christianity took over. Finds from the Roman period include a 7000-seat theatre, remains of synagogues, baths, a Roman colonnaded street and magnificent stone carvings. Parts of the city have been beautifully reconstructed and it is today known as "the Pompeii of Israel". In 749, the city was felled by an earthquake and it then fell into obscurity.

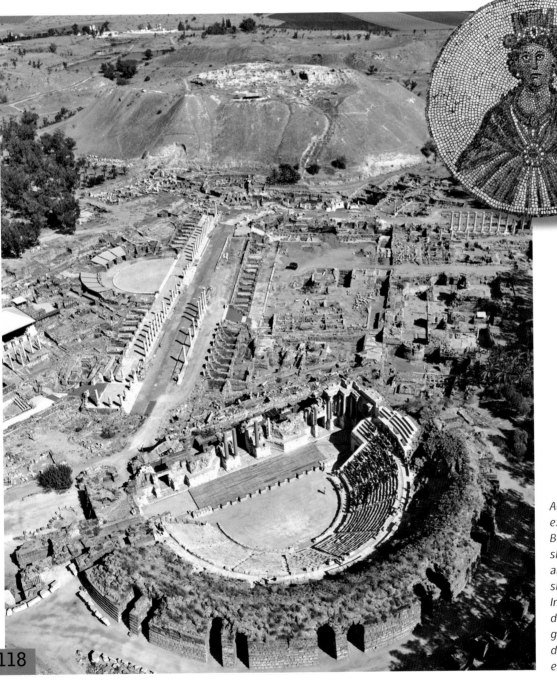

Aerial view of the excavations at Bet She'an clearly showing the theater and colonnaded street.
Insert: Mosaic depiction of Tyche, goddess of fortune, discovered in the excavations.

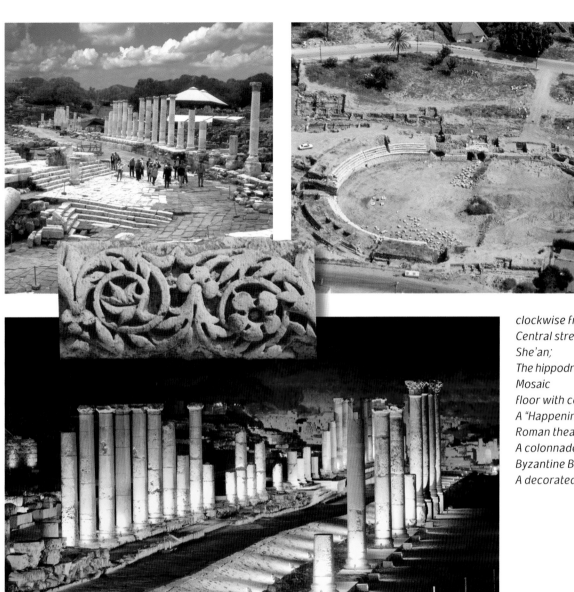

clockwise from top left:
Central street at Bet
She'an;
The hippodrome;
Mosaic
floor with columns;
A "Happening" at the
Roman theater;
A colonnaded street of
Byzantine Bet She'an;
A decorated capital.

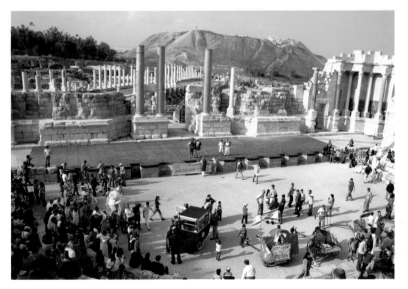

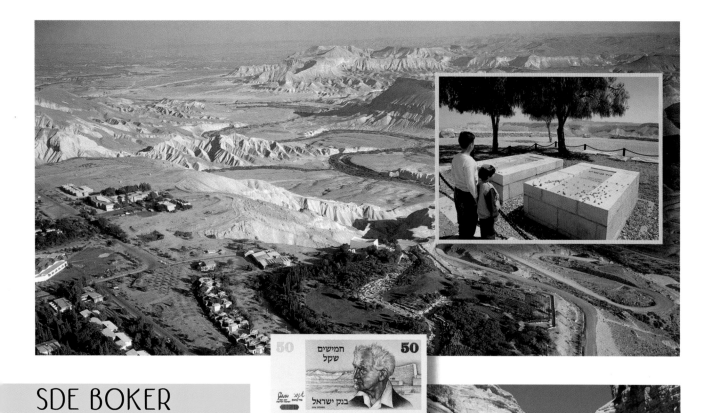

SDE BOKER

One year after the establishment of Kibbutz Sde Boker in 1952, David Ben Gurion made it his home. Israel's first prime minister had planned a great future for the Negev, to "make the desert bloom" and develop industry. At the Sde Boker Academy is the Desert Research Institute where scientists study the environment with a view to making the most of life in the desert. Ben Gurion and his wife, Paula, are buried in simple graves overlooking the wilderness of Zin.

above: View of the Wilderness of Zin.
insert: Graves of David and Paula Ben Gurion and banknote with portrait of Ben Gurion.
above: Avdat Spring
left: Kibbutz home of Ben Gurion.

EIN AVDAT

In Ein Avdat National Park is the Avdat Canyon which leads to Ein Avdat, a deep translucent pool. The narrow ravine of sheer white cliffs leads to the clear water which is fed by a small waterfall, icy cold in spite of the hot desert sun.

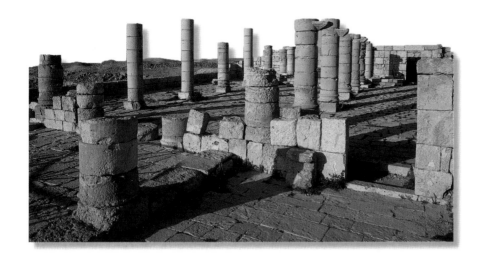

left: Remains of Avdat, the Nabatean city.
below: Views of the Ramon Crater with the Visitors´ Center
Nearby is the alpaca farm.

AVDAT

Avdat was founded in the fourth century BCE by the Nabateans, a trading nation who eventually controlled the caravan routes linking the Mediterranean to the Red Sea and across to Arabia, and up through Jerusalem to the north. Their capital was Petra. The ancient ruins of Avdat reveal the wonderful town planning and their remarkable system for water collection, storage and irrigation.

THE RAMON CRATER

The enormous Ramon Crater is surrounded by a superb moonscape of mountain peaks. At the Visitors' Centre of Mitzpeh Ramon, with the help of pictures, audio-visual programmes and models, youngsters and adults are introduced to some of the secrets of the Negev and can appreciate the wonders of geology. Trails have been marked out in the huge Park Ramon Nature Reserve.

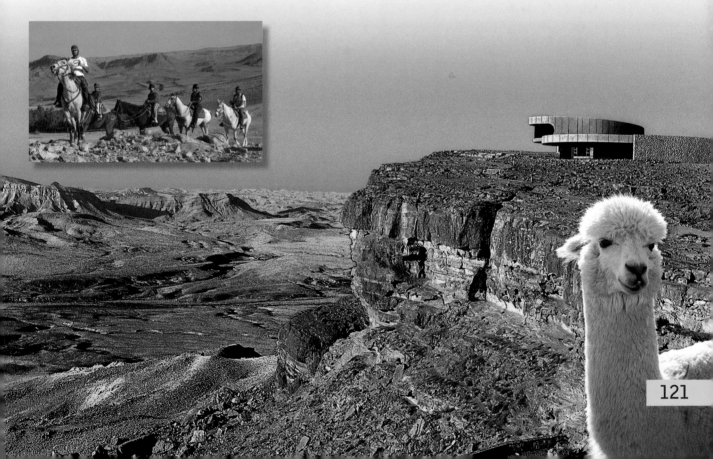

right: King Solomon's Pillars in Timna Park.
below: International Hot Air Balloon festival in Timna Park.
Insert: Reconstructed tabernacle as described in Exodus.

TIMNA PARK

The Timna Park Nature Reserve has awe-inspiring scenery; most of the rocks are sandstone like the famous "Mushroom" formation. An Egyptian temple to Hathor has been discovered here together with over 11,000 inscriptions and a Midianite shrine from the time of Moses.

SOLOMON'S PILLARS

The huge red sandstone rock columns, known as Solomon's Pillars, stand at the entrance to the Timna mines which have been producing copper on and off for 6000 years. They are entirely the work of nature – wind and water shaped these formations over the millennia. It is possible that King Solomon also mined copper here.

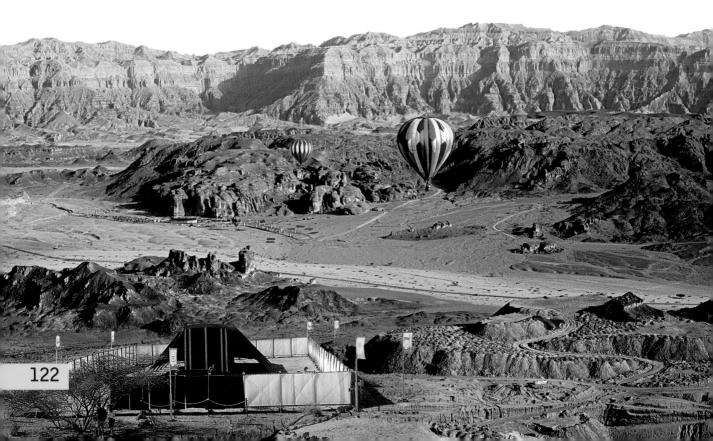

HAI BAR

In an area of 8000 acres of semi-desert, a successful attempt has been made at Hai Bar to restore to the Holy Land creatures which roamed here in Biblical times. Some have been imported from abroad, mainly from the East African savannah. Hai Bar is home to various horned animals such as the ibex, which alone of all the animals has remained in the Arava valley since biblical times, oryx, addax and gazelle. There are also ostriches, wild asses and many noctural fauna such as wolves, hyaenas, foxes and the desert lynx.

top: Desert scenery, clockwise from above: Asiatic wild asses; ibex; ostriches; addax.

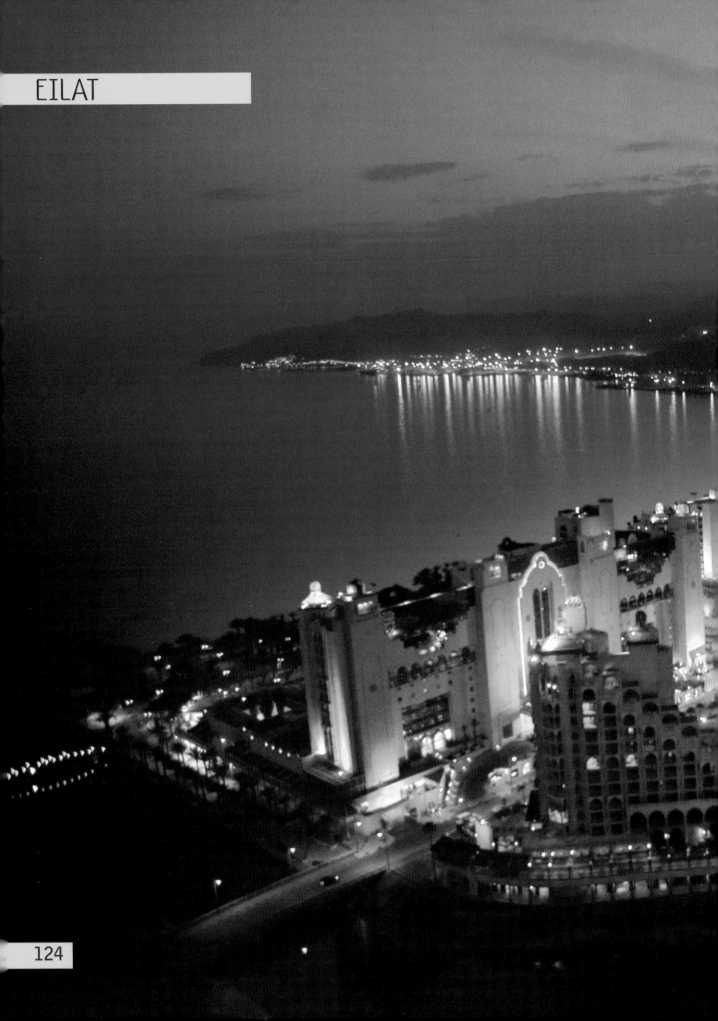

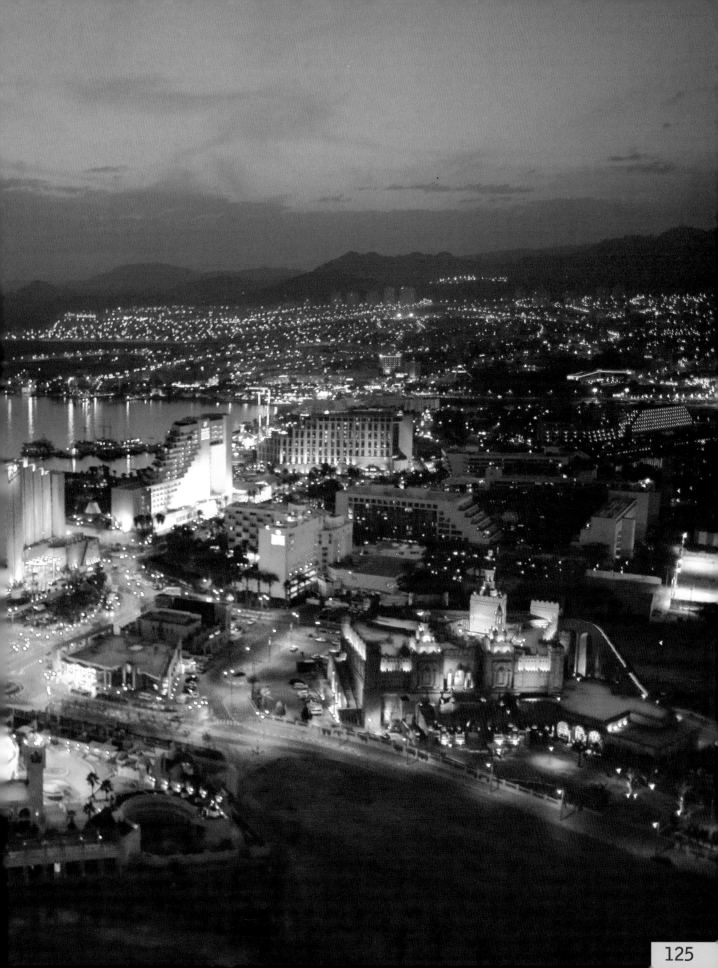

Today's Eilat was once known as Etzion Gaber, a port in the days of King Solomon. It was here that the Queen of Sheba came on her way to Jerusalem to visit Solomon. The port continued to flourish under the kings of Judah until a great storm that put an end to Jewish maritime commerce in the Red Sea for 3000 years. After the Muslim conquest the area was abandoned and when the Israel Defence Forces arrived in 1949, it was a derelict police post called Um Rash Rash.

Situated on a narrow strip of land where the mountains of Sinai and the Arava desert meet the Red Sea, Eilat is well known today as the place where the winter is always sunny and mild. Thousands of vacationers come to enjoy a relaxing holiday with swimming, sunbathing, water sports and desert tours in the magnificent surrounding area. There is a wide choice of hotels and restaurants all geared towards tourism, and the Israeli government has declared it a free trade zone. Among Eilat's attractions are the Dolphin Reef and some of the richest coral reefs in the world.

above: The Marina
below: Aerial view of the bay of Eilat.
opposite: Underwater scenery.

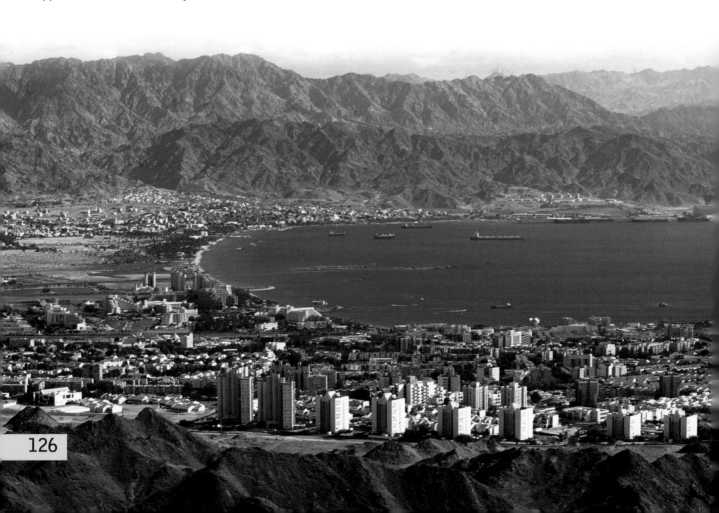

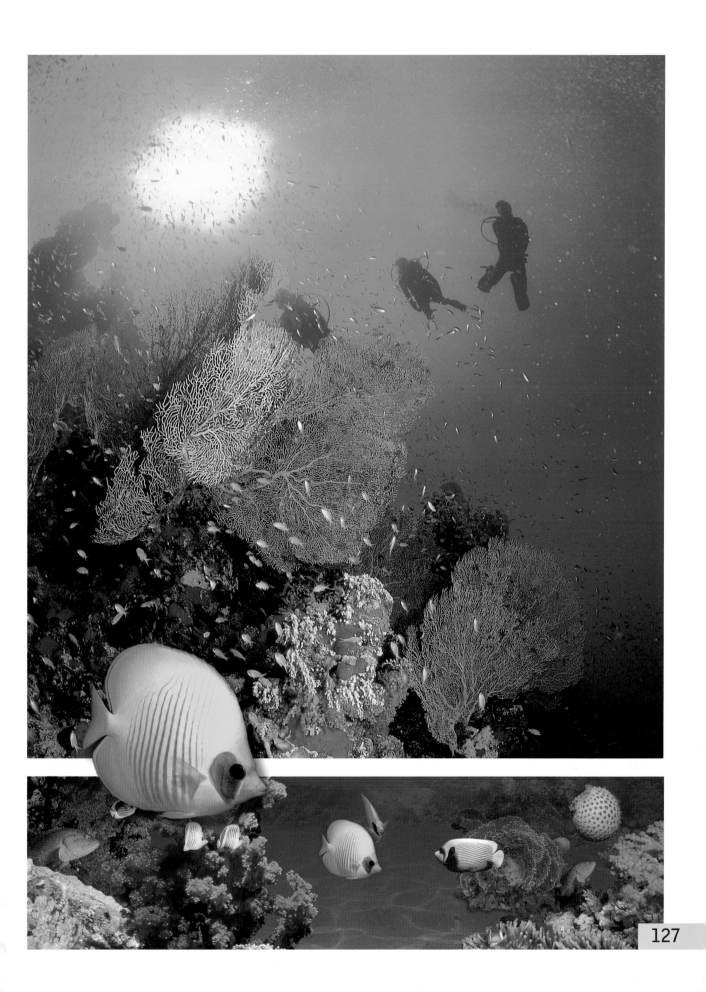

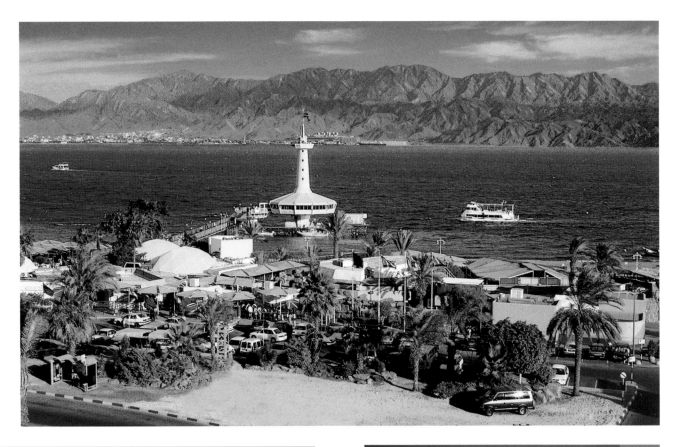

CORAL WORLD UNDERWATER OBSERVATORY MARINE PARK

One of the most popular sites in Eilat today is the Coral World Underwater Observatory Marine Park. Here the visitor can observe the splendors of underwater life in the Red Sea in air-conditioned comfort. The breathtakingly beautiful colours and shapes of the thousands of tropical fish and invertebrates that pass through the observatory enthral the visitor and also aid marine scientists in their studies of the coral reef environment. The complex includes a giant aquarium with 40 species of fish, two underwater observatories, several aquaria, a Shark Tank and a Turtle and Stingray Pool.

above: View of Coral World.
right: The underwater observatory.
opposite top: The ice rink at the Ice Park & Mall
opposite bottom: Aerial view of Eilat with King's City in the foreground.

King's City is a spectacular theme park, reminiscent of a royal palace, with multiple attractions. Visitors can take a voyage in time through caves quarried in the rock, and sail through Kink Solomon's halls where robots tell stories of the famous king in movement and sound. The tour ends in a journey towards an artificial lake through a huge waterslide. In the Voyage to the Past, all the most modern techniques are used to convey a sensory experience, including 3D and 4D films describing ancient Egypt at the time of the pharaohs. There is the cave of illusions with its numerous interactive

elements, and a Biblical cave which is reached by an elevator descending 60 meters into the earth. Here, the visitor can wander around and view presentations in which Biblical stories are narrated in sound and movement. After the labyrinths of the cave, he arrives at an amazingly beautiful stalactite and stalagmite cave, and discovers waterfalls and deer.

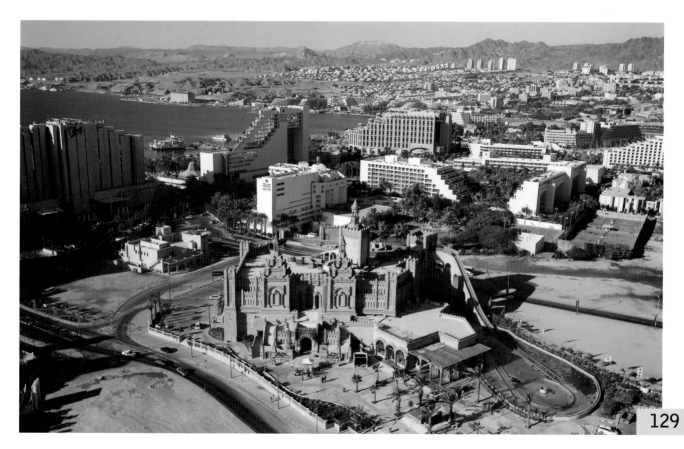

DIVING IN THE RED SEA

The Coral Beach – south of Eilat – is the venue for scuba diving or snorkelling. Here the seas are still unpolluted and the temperature of the water is almost constant throughout the year. The Nature Reserves Authority guards the coastline carefully to preserve the rich and colourful flora and fauna. It is forbidden to take corals or shells out of the sea, and fishing is only allowed at certain spots along the shore.

THE DOLPHIN REEF

A unique way of spending a day is with the dolphins in their natural habitat. An area in the Red Sea has been fenced off so they can be kept in open captivity and studied in their natural environment. Holiday-makers and these friendly mammals can consort together in complete safety. There are several ongoing therapy programs for people suffering from physical or mental handicaps.

TOURS FROM EILAT

As well as having sunshine all year round, Eilat is a convenient base for trips to many places of interest. At the Timna Valley Park, situated 30 kms north of Eilat, one can marvel at the ancient technologies and rock carvings, visit the remains of the Temple to Hathor, see rare rock formations and the famous Solomons Pillars. Also north of Eilat is the Chai-Bar Nature Reserve which aims to bring back to the area animals recorded in the Bible as indigenous. Other beautiful trips are to Ein Netafim

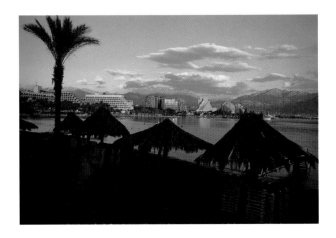

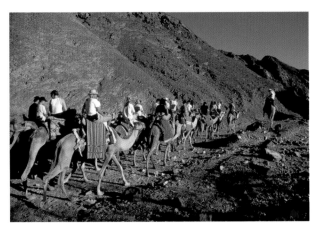

Views of Eilat and the surrounding area with its magnificent scenery.

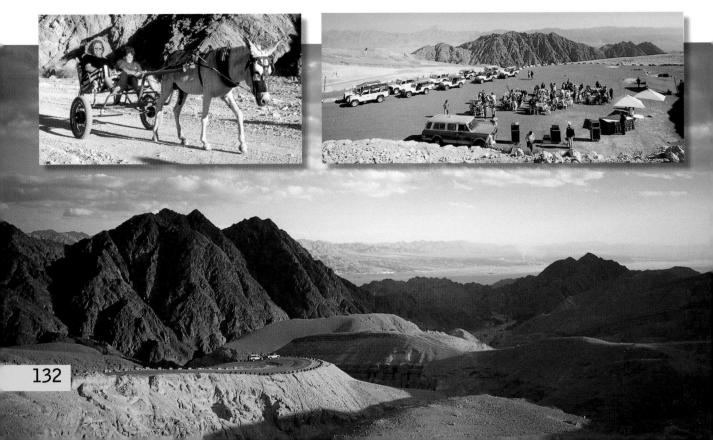

and the Red Canyon and other desert tours which the adventurous can make on the back of a camel. Among the natural wonders around Eilat is the Red Canyon, 600 meters long, where red sandstone gorges, some so narrow in parts that the red rocky walls almost meet, have been sculpted by erosion. Further south is the "Dripping" spring, Ein Netafim, whose waters are released reluctantly, drop by drop, into the pool below at the foot of the awesome cliff. This is a favorite water hole for the local wild life and in the early morning and late afternoon, visitors may see birds, lizards, mountain goats, rock rabbits, gazelles and even lynxes.

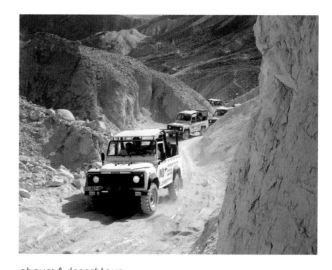

above: A desert tour
center: Amram's Pillars
below left to right: Petra, ATV vehicles near Eilat, the Red Canyon.

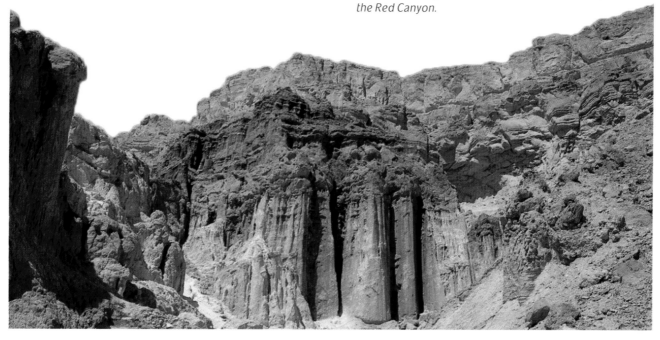

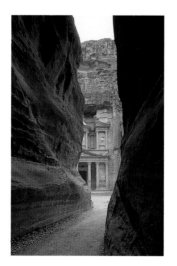

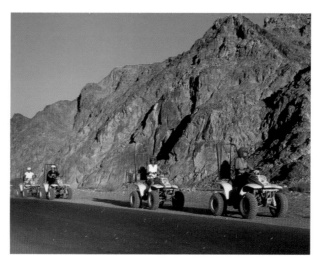

ISRAEL TODAY

HI-TECH IN ISRAEL

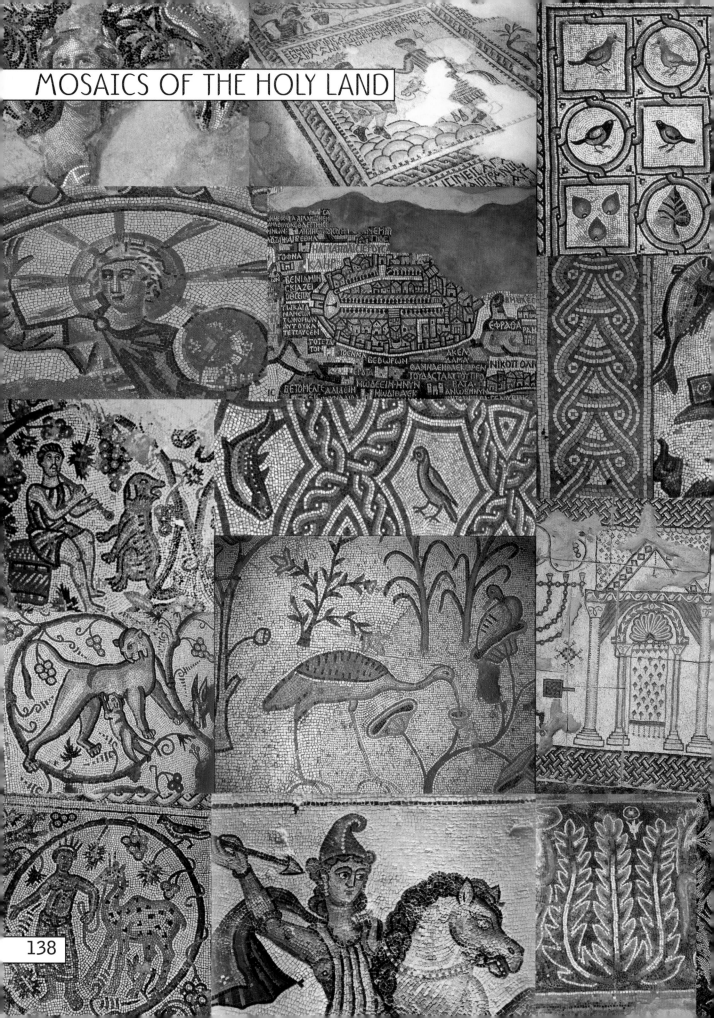

MOSAICS OF THE HOLY LAND

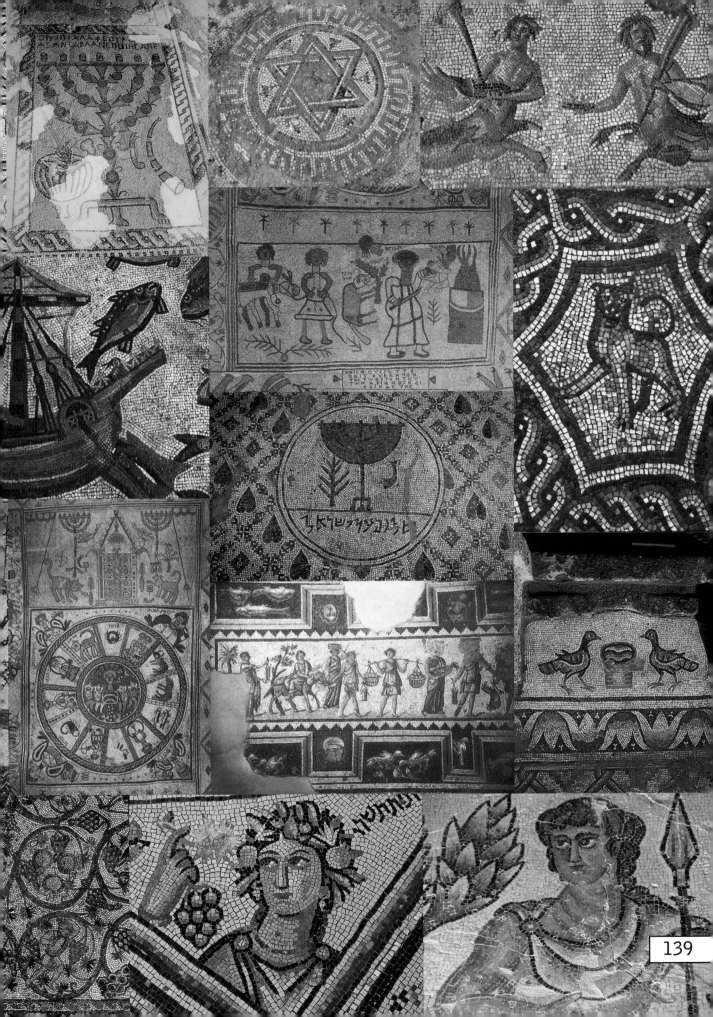

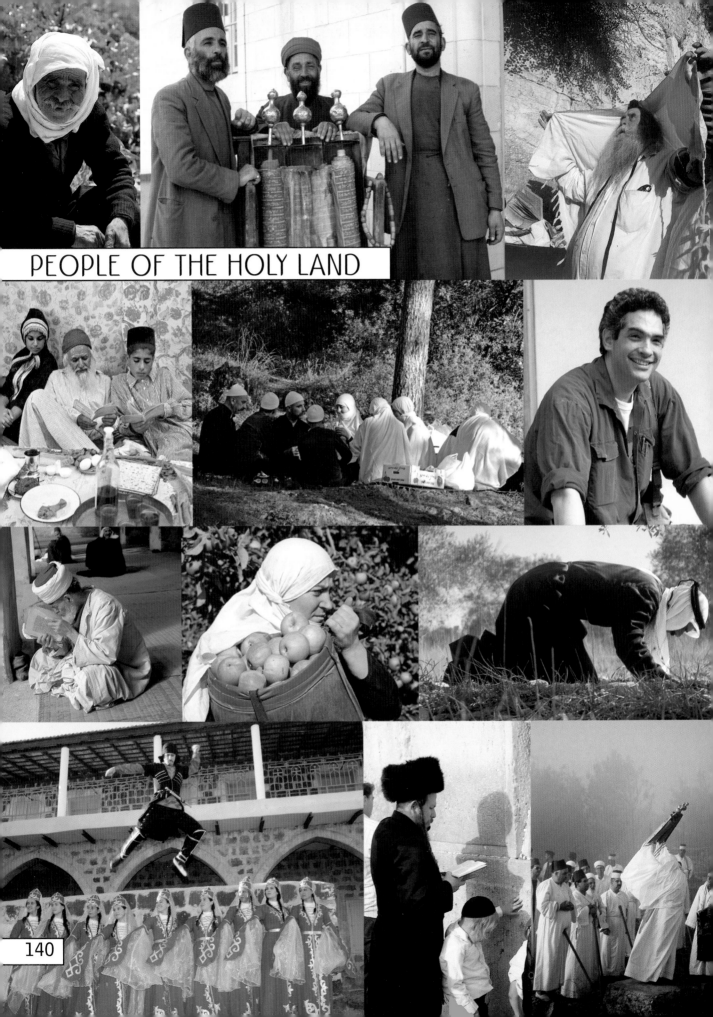

PEOPLE OF THE HOLY LAND

140

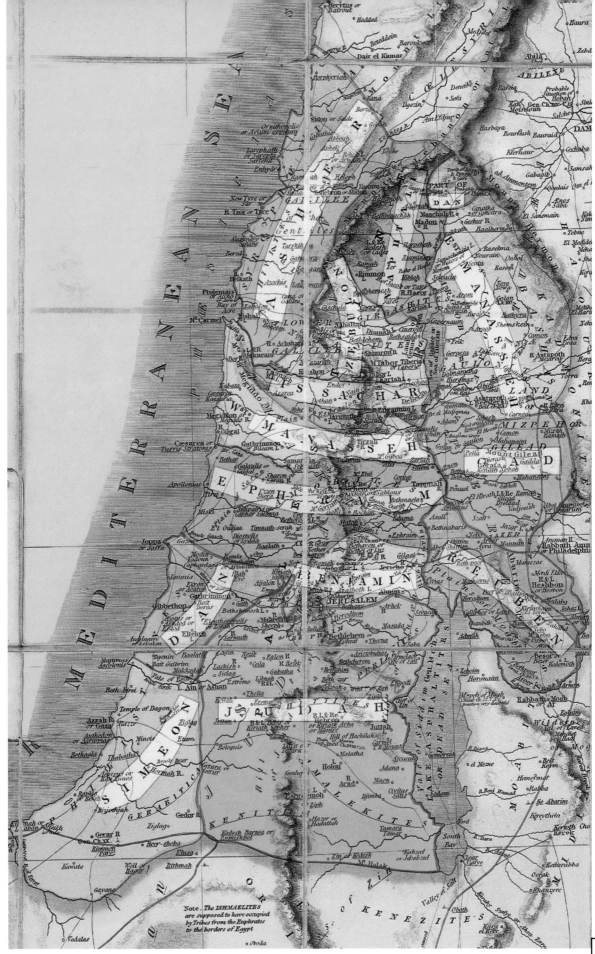

Eighteenth century map of the Holy Land divided among the Twelve Tribes.

Israel
Satellite Map

Rosh Hanikra

Acre

Haifa

Caesarea

Tel-Aviv

Jerusalem

Beersheba

Ramon Crater

Red Sea Fishes

Mt. Hermon

Jordan River

Tiberias

Nazareth

Bethlehem

Masada

Negev Desert

Timna Park

Eilat